ART
ANSWERS

Calligraphy

EXPERT ANSWERS TO
THE QUESTIONS EVERY
CALLIGRAPHER ASKS

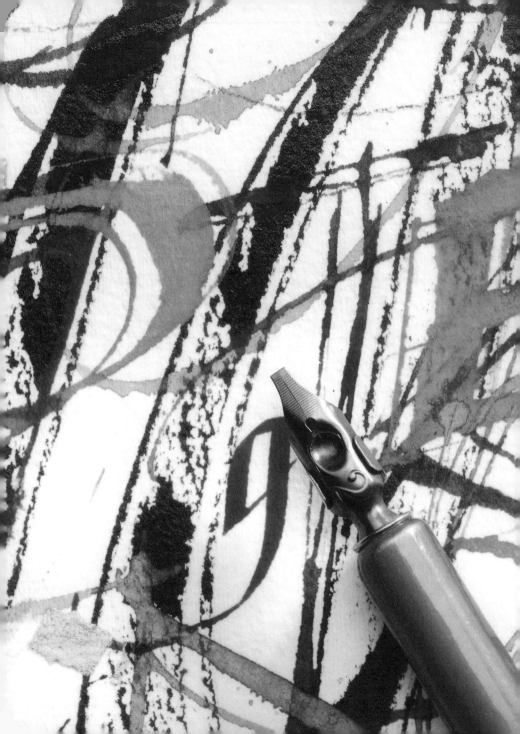

Art
Answers

Calligraphy

EXPERT ANSWERS TO
THE QUESTIONS EVERY
CALLIGRAPHER ASKS

CONSULTANT EDITOR:
MARYANNE GREBENSTEIN

Search Press

A Quantum Book

Published in 2012 by Search Press Ltd.
Wellwood, North Farm Road,
Tunbridge Wells,
Kent TN2 3DR

This book is produced by
Quantum Publishing
6 Blundell Street,
London N7 9BH

ISBN 978-1-84448-797-4

QUMAAC4

Publisher: Sarah Bloxham
Editor: Sarah Constable
Design: Joyce Mason
Managing Editor: Julie Brooke
Project Editor: Samantha Warrington
Assistant Editor: Jo Morley
Production: Rohana Yusof

Printed in China by
Midas Printing International Ltd.

Contents

Introduction

BY MARYANNE GREBENSTEIN

Calligraphy, the art of beautiful writing, is steeped in noble history and cultural richness. At its peak, it was used to create beautiful *Books of Hours* and other religious, scientific, astrologic and literary books during the fifteenth and early sixteenth centuries. Previous to that, it was seen in elaborately written and decorated manuscripts such as *The Book of Kells* and the *Lindisfarne Gospels* as early as the eighth century. Were it not 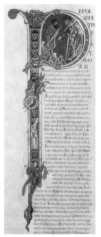 for the innovative calligraphy work of Edward Johnston (1872–1944), creator of the Foundational hand *(see page 86)*, calligraphy might not have risen from the dead following the invention of movable type by Gutenberg (1398–1468). Thanks to Edward Johnston's work, calligraphy resurfaced and was

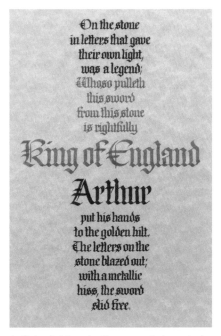

On the stone
in letters that gave
their own light,
was a legend;
Whoso pulleth
this sword
from this stone
is rightfully

King of England

Arthur

put his hands
to the golden hilt.
The letters on the
stone blazed out;
with a metallic
hiss, the sword
slid free.

Left to right on both pages: *A decorated letter from the twelfth-century* Winchester Bible; *a passage from* The Fall of Camelot; *calligraphy using gouache, written in a unusual circular format; an example of sharpened-italic style – a fifteenth–century angled form of the script.*

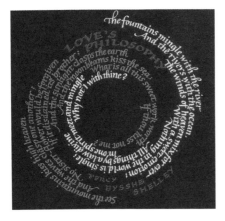

set on a path of revitalisation during the early part of the Arts and Crafts movement and it continues to enjoy popularity as an art form and foundation for a multitude of design studies.

This book, in an easy-to-use, question-and-answer format, includes calligraphic examples from many lettering artists working today. You will find directions here for practising the basic strokes that make up each letter, full alphabets with instructions for re-creating them and a section on tools and materials as well as suggestions on how to organise your workspace. There are expert tips throughout, advice on creating embellishments, borders and decorated letters and some important guidelines for the successful layout and design of your calligraphic work. Finally, there are projects that will show you how to use and develop your lettering skills to create unique books, posters, invitations and letterheads.

It is my hope that this book will provide inspiration and guidance for the novice calligrapher, tips to help the experienced

solve problems and design techniques for the more advanced. Photos and diagrams clearly illustrate the methods described, providing a reliable and useful reference for many years to come as the reader advances through new levels of expertise.

One aspect of calligraphy that may come as a surprise is its therapeutic quality. Because of its careful, deliberate strokes, it makes every calligrapher slow down, concentrate and let go of the day's busy demands. Therein lies one of calligraphy's most gratifying attributes. When forced to slow down and focus on the task at hand, we discover how joyful the creation of a thing of beauty can be!

Happy lettering!

Maryanne

Tools and Equipment

What kind of nib should I use?

Most calligraphers like metal dip pens, the type with a dimple, as shown below. The photo shows Mitchell roundhand nibs that are made in sizes 0–6, including some half-sizes: the lower the number, the broader the nib. For left-handed calligraphers, you will find that oblique nibs are also available.

When nib sizes are quoted in this book they refer to Mitchell roundhand nibs. Check your nib sizes against the chart shown below to see how your nibs compare in size. When working through the alphabets and projects in this book, hold your nib sideways and compare it to the chequerboard or ladder *(explained on page 42)* to be sure you are using the appropriate nib size.

Removing protective coating

With a new nib, be sure to remove the protective lacquer coating. Plunge it into hot water, or hold it briefly in a flame and then cool it in cold water.

MITCHELL NIB SIZES

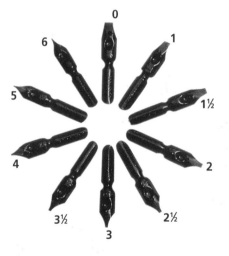

NIB SIZE CHECKER

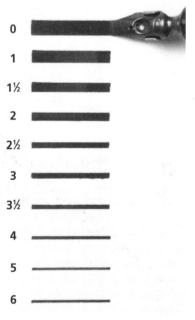

What kind of pen-holder should I use?

The photo below shows a selection of the holders that are available. Some calligraphers find rounded pen-holders more comfortable to use than faceted ones.

What kind of pen do I use for writing in Copperplate script?

If you are a right-handed calligrapher, you should use an 'elbow' pen or pen-holder. This special device helps to keep the very strong slope of the Copperplate letters (55°) consistent. It is fashioned to assist the right-hander to twist further to the right; hold the pen with the handle pointing roughly to your chest.

How does the reservoir fit on my nib?

A reservoir is a small metal attachment to the nib that holds a reserve of ink. Most small clip-on reservoirs fit on the bottom of the nibs used with assembled pens; you will need to make sure that it is fitted correctly to the bottom of the pen. You can do this by making some adjustments as shown here (below).

1 If the reservoir is too tight, pull the side wings apart slightly – it is made of brass and will not break.

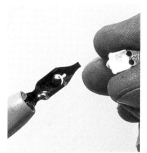

2 Try slipping the reservoir on again, holding it by the wings.

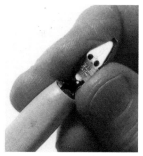

3 The reservoir should be loose enough to slip on and off without force, but not so loose it may fall off and drop into your ink.

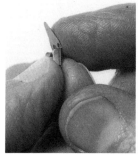

4 Take the reservoir off again and check the pointed end; it may have moved out of position following previous manoeuvres. Bend it inwards.

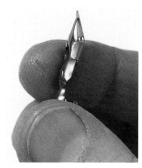

5 The point will be bent too far over the nib, but this is intentional at this stage.

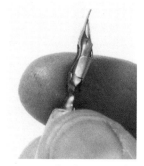

6 As you pull it down on to the nib, the point will be sprung against the underside of the nib so it will stay touching the nib to allow it to feed ink to the slit. Adjust it further down if the pen discharges too much ink.

How do I hold my pen?

Hold the handle close to the nib with your thumb and first two fingers. Twist the handle a little between the fingers until you can feel when the whole width of the nib is in contact with the paper; try a thick stroke, then a sideways thin stroke.

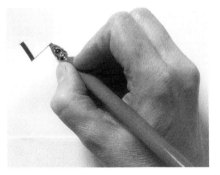

How do I hold my pen if I am a left-hander?

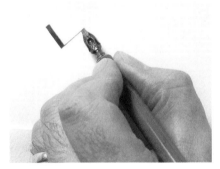

Twist your wrist a little so that you can hold the straight edge of the nib at the required angle; if you have a left oblique nib, you will not need to twist far. You may find it more comfortable to move the paper to the left of your body, but make sure you can still see what you are doing.

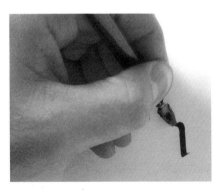

Left-hander 'overarm'

If you normally write 'overarm', consider writing the letters in a different stroke order, from bottom to top, so that you can still pull the ink.

> **EXPERT TIP**
>
> *When you are writing 'overarm', you need to take care not to smudge the writing with your arm.*

Can I use a fountain pen for calligraphy?

Although not recommended for high-quality artwork, fountain pens are useful for practice for the beginner. There are various calligraphic fountain pens on the market. Some are purchased as an integral unit (that is, a complete pen); others are bought as a set and include a barrel, reservoir and a set of interchangeable nib units. It is best to avoid the cartridge refill as it limits the colour of the ink that can be used in your fountain pen. It is better to buy one that has a squeeze-fill reservoir so that the colour can be changed quite easily.

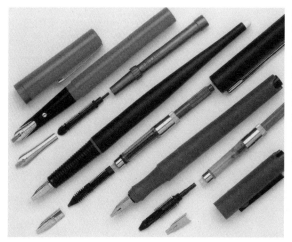

Left: Three kinds of fountain-type pens. The top two have a variety of interchangeable nib units. The third art pen is a complete unit available in a number of sizes. The ink holders, or reservoirs, are of either the squeeze or piston type and all three types of fountain pens have an optional cartridge ink supply.

What is a crow quill?

A crow quill is a very tiny pointed metal pen nib. It is used for drawing very fine lines and is also known as a mapping pen. It is sometimes used for Copperplate writing.

What is a poster pen?

In contrast to a crow quill, a poster pen is a very large broad-edged pen nib. It is used for writing large letters, such as those used for posters, hence its name.

Left: A crow quill.
Below: A poster pen.

How do I make a quill pen?

If you want to make your own pen, there are many excellent sources of quills: the primary flight feathers of geese, swans and turkeys are ideal. For delicate work, crow and duck quills provide a very fine shaft. The natural curve of the quill is important, so that the instrument sits comfortably in the hand. Left-handed calligraphers should select quills from the right side of the bird and right-handed calligraphers from the left.

HOW TO DRY AND CUT A QUILL

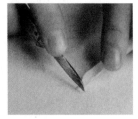

1 Strip the barbs from the shaft. Using the back of a penknife, scrape the length of the barrel to remove the outer membrane. Rub the shaft with a rough cloth.

2 Before cutting, the quill must be hardened and clarified. First, cut off the sealed end of the barrel, then soak the quill in water overnight. The next morning, heat some sand in a shallow tray or pan. Take the quill from the water and shake it vigorously. The pith-like centre should be removed. Spoon hot sand into the barrel and, when it is full, plunge it into the heated sand for a few seconds. Then cut the top off the quill.

3 Make an oblique cut, long and slanting, downward to the top of the quill.

4 Make another oblique cut below the first to shape the shoulders of the quill. This gives the familiar stepped arrangement of shoulders and nib tip. Remove any pith remaining in the shaft. Make a small slit in the shaft to aid the flow of ink down to the writing tip.

5 Work on a smooth, hard surface, such as glass, for the final shaping. There are two ways of holding the nib for this stage. The first is to rest it on the edge of the glass, underside down. Alternatively, place the nib underside uppermost and hold it firmly. Carefully make a clean cut down the nib tip in a single vertical movement. Pare the nib finely and obliquely on the top side to complete the quill.

6 Use a brush to load the quill pen with ink, and begin to write. If used often, the nib will need to be recut.

How do you cut a reed so it can be used as a pen?

A reed pen can be made easily and cheaply. Garden cane is available and provides an equivalent of the original type of reed. The hollow cane is easily cut to length and shaped, using a sharp knife to form a writing nib. Inspect the cane very carefully to make sure it has no splits or imperfections.

MAKING A REED PEN

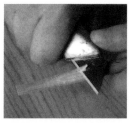

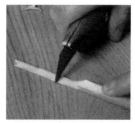

1 You will need a suitable reed or cane, a sharp knife, and a hard cutting surface. Soak the reed or cane for at least 15 minutes, then cut it while it is still wet to about 20cm (8in). The first cut is an oblique slash down toward one end.

2 Shape the shoulders of the nib. Then, using the point of the knife, clean out any pith inside the cane that has been exposed by the first cut.

3 Firmly hold the pen on the cutting surface and trim the end to nearer the eventual nib length. Turn the pen through 90° and make a small slit down the centre of the nib, at a right angle to the writing edge.

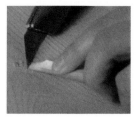

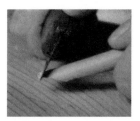

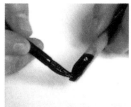

4 If the nib seems too thick, very carefully pare it down to make it thinner. Holding the nib underside up, make a vertical cut across the nib end.

5 Make a small diagonal cut on the upper side of the nib, down towards the end. This will produce a fine writing edge.

6 The reed pen is now ready to use. A brush is used to transfer ink on to the underside of the nib.

How do I write with a reed pen?

In comparison with the quill, the reed pen has less flexibility. It cannot sustain such fine and accurate shaping and the overall effect of work written with this pen may not be as elegant. It does have excellent qualities, however, which make it a valid implement for many styles of writing. The calligrapher can select canes of different sizes and prepare a varied range of nib widths accordingly. The resulting bold letterforms are highly effective in poster work, headings, and titles, and can be matched to specific 'one-off' jobs where a particular nuance is sought.

The cane, being a hollow tube, provides an excellent reservoir for ink. To ensure it does not flood the writing, work on a flat or only slightly inclined surface. As with most calligraphic implements, the reed pen resists a pushing motion and you obtain best results from pulling the stroke.

USING A REED PEN

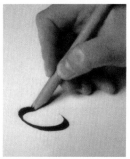

1 A reed pen has a different 'feel' to a metal-nibbed pen; because it is made all in one piece, it feels almost like an extension of your hand and is very pleasurable to use. The width of the strokes made with a reed pen is dictated by how wide the nib has been cut. This illustration demonstrates the firm and solid strokes that this simple instrument is capable of producing.

2 The reed pen has the ability to produce both the extremely fine lines and the thick strokes required for calligraphy. Holding the reed pen at the prescribed pen angle, a fine line is extended from the tail of the letter. To complete the line the right-hand side of the nib is lifted off the paper, and the left-hand side of the nib drags wet ink into a hairline.

3 The lower-case letters *(left)* are written confidently, and show how a nib made from an inflexible material can produce very well the familiar characteristics of calligraphy.

4 When working with a reed pen, always keep the top side of the nib clean. Take care not to overload with ink, as this could result in blotting or smudging. This example shows an excellent balance between the thick and thin strokes and a fine hairline extension to the last letter. This was performed by dragging wet ink with the left-hand corner of the nib.

What is a ruling pen and how do I use it?

A ruling pen is an excellent instrument for drawing up rules of various widths. It can be used with ink or paint, so is versatile for introducing or enhancing colour work. The pen consists of a handle to which two stainless steel blades are attached. One blade is straight and flat, the other bows slightly outward. The tips of the blades almost meet: the space between them forms a reservoir for ink or paint. By adjusting a thumbscrew on the bowed blade, you can alter the distance between blade tips, which dictates the thickness of the line made by the ruling pen.

Loading the pen

Load the medium into the pen with a brush, or using the dropper supplied with some ink bottles. No ink or paint must be left on the outer edges of the blades, as this could flood the paper if it comes into contact with the ruler used to guide the pen. The pen must be operated with both blades resting on the paper. Its movement discharges the fluid held between the blades.

Although the thickness of the line can be considerably varied by adjusting the pen, some rules may be of a thickness that is best achieved by drawing two parallel lines and filling in between them with a small brush.

For fine work, the ruling pen has perhaps been superseded by the technical drafting pen (which is also available as a compass attachment), but the ruling pen remains unsurpassed for the ability to produce rules of different weights and colours.

USING A RULING PEN

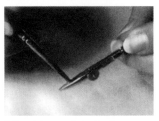

1 Use ink or paint mixed to a fluid consistency. Insert the colour between the blades of the ruling pen with a dropper or brush. Wipe off any excess medium from the edges of the blades.

2 Place the ruler flat on the surface with the bevel edge sloping inward and hold firmly. The thumbscrew on the curved blade of the pen should face outward. Hold the pen at a slight angle to the ruler to avoid paint or ink flooding underneath the edge. Keep the drawn stroke light and steady, with the points of both blades on the paper to ensure an even flow of medium. It may be necessary to do a 'trial run' to check that the width of the line is correct.

How do I use a compass attachment with a ruling pen?

A ruling pen attachment is often found in a standard compass set. It can be used in place of the pencil lead normally inserted in the compass, so that you can draw perfect circles of ink or paint.

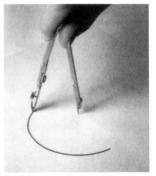

Load the blades of the compass attachment with liquid medium, place the centre pin of the compass on to the paper and draw the blades over the surface.

Can I use a brush to rule lines?

Yes you can, but you need to be careful that you avoid smudging. Smudging can be avoided by holding the ruler at a 45° angle to the paper so that the edge is not actually touching the paper. Gently draw the brush along the ruler, keeping the ferrule against the ruler's edge to ensure a straight line. When the line is completed, remove the ruler carefully to avoid smudging.

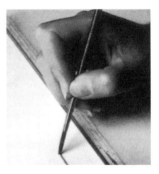

Can a ruling pen be used for writing?

Yes, a ruling pen can be held in such a way that the space between the two points acts as a broad-edged nib. This allows the calligrapher to write with the ruling pen, once it is loaded with ink or paint. Look at the example here *(right)* – this free-form lettering has been written with a ruling pen.

What kind of ink should I use?

To produce the clean, sharp strokes that characterise calligraphy, your pen and your ink must be compatible. The inks used by medieval scribes were efficient and durable. However, inks that had been suitable for quills frequently corroded metal pens and during the nineteenth century alternative inks were developed. Some calligraphers continue to make inks from old recipes for creative purposes, but nowadays there are a great number of prepared inks from which to choose.

Types of ink

It is fun to experiment with inks once you have gained confidence, but for now there are only two factors to consider. The ink must flow smoothly and be an intense black, even when dry. Some inks appear black at the time of writing, but dry to a disappointing grey. For smooth flow, the ink must be non-waterproof.

You can buy non-waterproof ink ready for use or in a thick solution to be diluted with water. Use distilled water, not water from the tap, or the ink will deteriorate. Remember to keep the lid on so that the ink does not dry around the top of the bottle and flake into the liquid.

The introduction of colour in the pen strokes or background opens up a vast range of creative possibilities. The paints generally used by calligraphers are artists' watercolours, gouache (an opaque form of watercolour) and some liquid acrylics.

> **EXPERT TIP**
>
> *Never shake your ink bottle, as the air bubbles will make ink flow in your pen difficult. Ink gets darker and more permanent as it dries. Try leaving the top off your bottle of ink for a few days before using the ink, so that it becomes darker.*

INKS
Both the black calligraphers' ink you use and the coloured inks should be non-waterproof, as the shellac in waterproof inks can clog the pen.

LIQUID ACRYLICS
Only water-based inks are suitable for use in the pen. Liquid acrylics mix better than acrylics from the tube.

What is stick ink?

Chinese stick ink is popular with calligraphers because it does not clog the pen. The ink is sold in sticks *(right)* in varying colours, which have to be rubbed down with distilled water. Ink stones are used for this process.

To use stick ink, pour distilled water into the central well of the rubbing stone *(also shown right)* and push the ink stick back and forth in the water against the abrasive surface of the stone. You can vary the thickness of the ink by increasing or reducing the amount of ink grinding. Don't store stick ink when it is still wet as this will cause it to flake. Always wash your ink stone after use.

What is the best mixing dish to use?

The best mixing dishes are white ceramic because they don't stain. They come in a variety of sizes and shapes, such as the ones shown here *(below)*.

Below: *Mix your paint on a palette or mixing dish. Use distilled water if you plan to store the paint.*

What type of pencil should I use?

There are two types of pencils suitable for calligraphers. The first is a standard drawing pencil, such as the ones shown here *(below right)*. They are used for drawing rough and thumbnail sketches and pencilling in your text before inking. The other type of pencil is a mechanical pencil *(below left)* that is used for drawing pencil guidelines. A lead thickness of .5 or .3 is best for this purpose.

What kind of eraser is best for erasing pencil guidelines?

White plastic erasers are best for this work, like this one *(right)*.

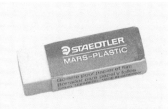

What type of ruler is best for calligraphy?

A metal ruler, preferably with a cork backing, is the best type *(below)*. The cork back raises the metal edge off the surface of the paper very slightly, which prevents the ink from being drawn under the ruler.

What sort of cutting tool should I use?

A surgical scalpel is useful and has an exceptionally sharp edge. Replacement blades are sold in units of five per packet. Do be careful when changing the blade – it will be extremely sharp and should be treated with great respect. Always remove the blade by lifting it first from its retaining lug and then with your thumb, push the blade away from the body. Keep your fingers well away from contact with the cutting edge. When fitting a new blade, slide it carefully on to the retaining lug, grip the blade on the blunt top edge and push it home. Be sure to keep your scalpel stored safely *(see Expert Tip below)*.

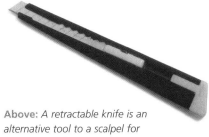

Above: *A retractable knife is an alternative tool to a scalpel for precision cutting.*

CHANGING A SCALPEL BLADE

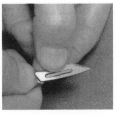

1 Ease the scalpel blade from its mounting using your thumbnail.

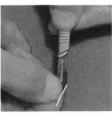

2 Pull the blade from the handle mounting by grasping the blunt edge.

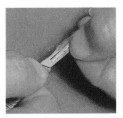

3 Place the new blade on the handle mounting.

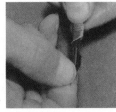

4 Push the blunt edge of the blade firmly on to the mounting gripping.

EXPERT TIP

When the scalpel is not in use, use a cork to prevent accidents and avoid blunting the blade.

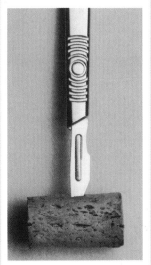

Handmade paper

Cold-pressed paper

Hot-pressed paper

Pastel paper

Mould-made pastel paper

Cover paper

What kind of paper is good for calligraphy?

There are many kinds of art paper on the market, including handmade paper, cold-pressed, hot-pressed and other types *(left)*. When choosing paper, you need to consider its weight and its surface carefully. The weight, which indicates the thickness, is especially important when using painted backgrounds.

Surfaces are graded as hot-pressed, cold-pressed, or rough according to the processes used to dry the paper. Porosity is affected by the addition to the paper of a gluey substance known as size. Unsized or poorly sized papers allow ink or paint to spread, or 'bleed' into the fibres, and too much size can make the surface too resistant.

Test a paper's suitability by trying it out with a pen: if the surface drags or catches in the nib, or the ink bleeds, it is probably unsuitable. However, certain surface difficulties can be overcome. Highly coated, glossy papers should be rejected because the ink is likely to stand in blobs on the surface.

PAPER SAMPLES

Build a collection of paper samples that interest you, storing them in a folder. Label each paper and add observations on how it affects nib movement and how it interacts with ink and paint.

What kind of paper should I avoid using for calligraphy?

Becoming familiar with different types of paper will enable you to choose the best surface for your work. Knowing the causes of paper problems can be helpful – these examples *(below)* show common ones that you may encounter.

SURFACE TOO ROUGH	SURFACE TOO SLIPPERY	TEXTURED PAPER
Ink flow is impeded and this makes it difficult to guide the nib steadily and smoothly.	The nib cannot be controlled. In this situation, ink builds up on the surface and may run into lower lines.	Surface bumps may distort writing and may contain hairs that are picked up by the nib.

UNSIZED OR WATERLEAF PAPER	UNEVEN SIZING	GREASY SURFACE
Absorbs ink or paint like blotting paper.	This causes the letters to 'bleed' in patches.	This resists the writing medium. Grease spots can cause the same problem.

What is gold leaf?

Gold leaf *(right)* is very thinly pounded gold, sold in small booklets. It is used for decorated letters and for border illumination *(see pages 180–181 for details of the technique and types of burnishers).*

What is gesso?

Gesso is a medium and is used for many purposes. It is the substance gold leaf adheres to in decorated letters. Acrylic gesso, sold in cakes in most art stores, is mixed with distilled water to soften and then applied to the area to be gilded *(left).*

You can also make gesso by following medieval recipes. If the gesso has been made to the traditional recipe containing white lead, take care to wash your hands afterwards and store the unused gesso safely.

What is sandarac?

Powdered gum sandarac, applied to the paper through a porous bag, makes a writing surface more resistant to ink; if sandarac is rubbed rather than dusted, it will roughen the surface slightly, which may help if the paper is slippery *(below right).*

Left: *Gum sandarac is bought in crystals. Grind these to a fine powder with a mortar and pestle.*

What is a T-square?

A T-square is a ruler in the shape of a 'T' and is used to help you rule guidelines. The 'T' portion rests against the side of your drawing board. As the T-square is moved up or down the drawing board, it provides a straight edge with which to draw parallel lines. You need only mark the line depths along one margin.

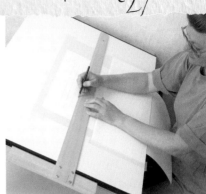

Is there another tool that could be used for lining up my pencil guidelines?

Yes, you could use a ruler and set square to help keep the lines parallel. They will help you to rule straight and accurately spaced lines to guide your writing. The sequence of photographs *(below)* will show you what to do.

USING A RULER AND SET SQUARE

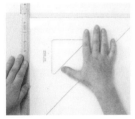

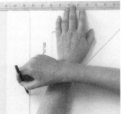

1 Place the ruler along the left-hand edge of the paper. Hold the set square against the ruler and slide it up to the top edge of the paper. If the top edge of the set square does not align with the paper, the paper is not square and should therefore be trimmed accordingly.

2 Place the ruler along the top edge of the paper. Slide the top edge of the set square along the ruler until the left-hand edge of the set square is in the position in which you wish to place your left margin. You can then lightly rule the margin in pencil.

3 Place the ruler along the ruled left margin. Slide the set square down the ruler until the top edge is in the position in which you want to place your first writing line. Lightly rule a line. Continue to move the triangle set square down the ruler and rule as many lines as you want.

CHAPTER
2
Organising Your Workspace

What should I consider if I buy a drawing board?

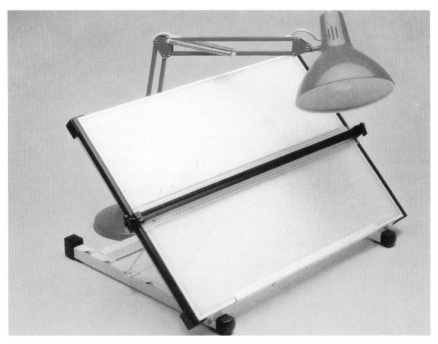

Above: *A True-line drawing board with parallel motion.*

A drawing board with adjustable angles can be purchased from most art shops. There are many varieties of drawing boards available for sale. One important consideration is whether you want a board with a parallel motion (also known as parallel rule), as shown. This added tool eliminates the need for a T-square, but not all calligraphers prefer the attached ruler. It is a matter of personal preference. The most important consideration is the sloped writing surface. Another factor to

consider is the size of the work surface – a small area will limit the paper size you can comfortably work on. It is generally recommended that a minimum of 450 x 600mm (18 x 24in) work surface will be required.

Additionally, the construction material should be considered if the drawing board is to be ordered over the Internet and shipped to you. If it is very heavy or too fragile, shipping could be problematic or expensive.

Alternatively, can I make an adjustable one myself?

Yes, it is possible to make your own professional-looking board *(below left and right)* if you have good woodworking skills – alternatively, you could find a carpenter to make one for you. This style of home-made board adjusts at the back to three angles so that you can alter it to suit your needs.

For a board like this, you will need to buy laminate board and cut two pieces for a base and top. From the same material, cut another piece for the board support. You will also need some softwood for support battens, table stop and board-base spacer. All of these items measure the same width as the drawing board. In addition, six butt hinges and some chipboard screws are required to complete the board.

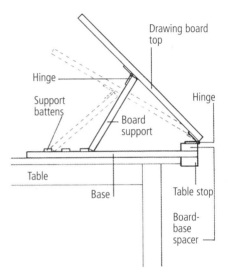

Drawing board top

Hinge

Support battens

Board support

Hinge

Table

Base

Table stop

Board-base spacer

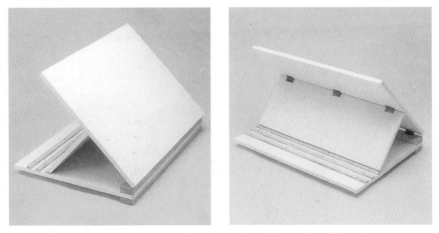

Above left and right: *A home-made drawing board with three adjustable angles.*

What is a freestanding board and can I make one?

A freestanding board is an alternative to an adjustable board – and you can make one yourself. Laminate shelving board is quite adequate. A suitable board size is 450 x 600mm (18 x 24in). Apply iron-on laminate edges to give a clean finish.

The board can be supported on your lap and leant against the edge of a table or desk *(below)*, making an angle of about 45° with the desk top.

Board should be padded *(see page 33)*. Use a guard sheet when writing to prevent perspiration from your hand affecting the paper.

No tape over edges where T-square runs.

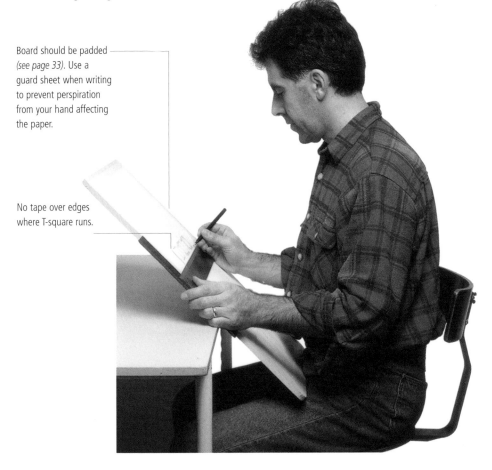

How do I pad my freestanding board?

For writing comfort, many calligraphers prefer to letter on a surface with a little 'give' to it. For that reason, they pad their drawing boards. It's an easy process – the steps here *(below)* show how it is done.

YOU WILL NEED
Drawing board
2 sheets blotting paper or several
 sheets newspaper
One sheet white paper
Masking tape
Iron, if using newspaper

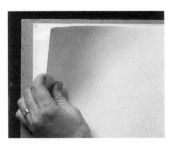

1 To pad the board, use two sheets of white blotting paper or several sheets of newspaper with creases ironed out, covered by a sheet of white paper. Cut them to fit the board, allowing room for the tape.

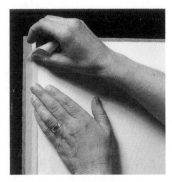

2 Fix the paper down all round with masking tape. Take care not to go over the edge with the tape if you intend to use a T-square.

3 The final touch is a narrower sheet fixed across the board with the top edge at writing level. Tape it at the sides and leave the bottom open for your writing paper to be slid up and down.

What is the best angle (slope) for my drawing board?

In calligraphy, work is carried out with the drawing board at an angle. Never work on a flat board.

You should be positioned in front of the work so that you can see it clearly without stretching. Writing on an angled board gives you a good overall view of your work as it progresses and will moderate the flow of ink when you come to write with the pen. A raised board will also discourage you from leaning over your work.

For most writing, the board needs to be raised at an angle of 30–45°; you should find the position that suits you best within these guidelines. Four ways of raising your board are shown *(left and below)*.

1 Prop the board against the front edge of the table and rest the base in your lap.

2 Place one end of the board on the table and lean the other end on books or covered bricks. Secure the board against the table edge with a thin strip of wood held in place at each end by two small clamps.

3 Buy a ready-made designer's drawing board and adjust it to the angle you require.

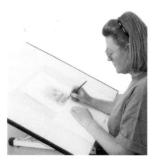

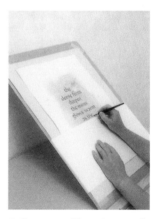

4 Place your table against a wall and lean your board on the wall at the desired angle. Secure the board against the table edge with a thin strip of wood held in place at each end by two small clamps.

What is the best writing position?

The way in which calligraphers sit and hold their pen varies from person to person, but it is important when beginning calligraphy to sit correctly and use the recommended pen hold. The way you sit will be directly reflected in your writing. If your body is tense and angled, your hand and arm will be restricted and your writing will not flow. A poor writing position produces awkward and inconsistent letterforms and this can be very disheartening. You need a posture that optimizes controlled but fluid movement. This means considering the position of your body and the angle of your board *(right)*.

Use a table and a chair whose relative heights enable you to keep your board at the chosen angle. A table that is too low or a chair that is too high will place you in an uncomfortable position and will, in effect, flatten the angle of the board.

CORRECT POSITION

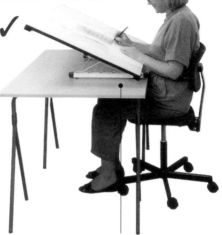

Above: *The height of your table and chair should be adjusted to allow you to work with both feet placed side by side on the floor. This will ensure steadiness and reduce tension. By angling your board, you can work without leaning forward.*

✗ CROSSED LEGS

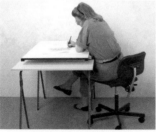

Crossed legs and a twisted body angle make it difficult to achieve good writing. This position may seem extreme, but it is not unusual.

✗ LEANING TOO FAR

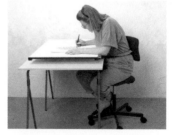

Avoid the temptation to lean forward, as doing this will inhibit your arm movement and affect your writing.

How important is lighting at my work station?

Correct lighting is as important for the eyes as posture is for the limbs. Tired eyes and limbs are not conducive to clean, crisp calligraphy. Ideally you should work in daylight. If you are right-handed, the light source should be from the left, and if left-handed, from the right. Light, correctly directed, should ensure that you are not working in your own shadow cast by the writing hand. Lighting therefore plays a key role in the laying out of the working area. Strong direct light, such as sunlight, should be avoided, as excessive glare from the usual white surface being worked will make lettering difficult.

You will also need artificial light from a desk-lamp – an anglepoise or similar – or a wall-mounted or floor-standing unit. The direction of the light source is the same as for daylight. The advantage of an anglepoise lamp is that of ease of direction or position; for intricate work, light can be directed to the point required by simple adjustment.

LIGHTING CHECKLIST

The type and direction of the light by which you work will affect the quality of your calligraphy. The aim is to have good lighting without shadows cast over your work. Take note of the following guidelines:

✓ Good daylight is preferable.

✓ Artificial light is best provided by an adjustable desk-lamp.

✓ 'Daylight' bulbs give the best artificial light, especially for work in colour.

✓ Position your light source to avoid shadows on your work. Light should come from your left if you are right-handed *(see diagrams, right)* and from your right if you are left-handed.

 Light from left; no shadows on work.

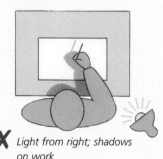

✗ *Light from right; shadows on work.*

ARTIFICIAL LIGHTING OPTIONS

A selection of lamps suitable for
this are shown here. The two angle-
poise lamps are the best options as
they can be adjusted and brought
in close to your work. The floor-
standing anglepoise lamp (**1**) offers
good flexibility for positioning and
saves desk space.

Basic Strokes

What are the different parts of the letters called?

In order for you to fully understand letter construction, you will need to become familiar with the terminology used to describe various parts of the letters. Study the chart below to learn this nomenclature. Many descriptions are repeated from letter to letter as these terms are used generally throughout the alphabet and are not necessarily confined to a specific letter. The parts and names illustrated refer to the Quadrata capitals (majuscule) and a complementary lower-case (minuscule) alphabet, although most of the terms can be employed to define other forms.

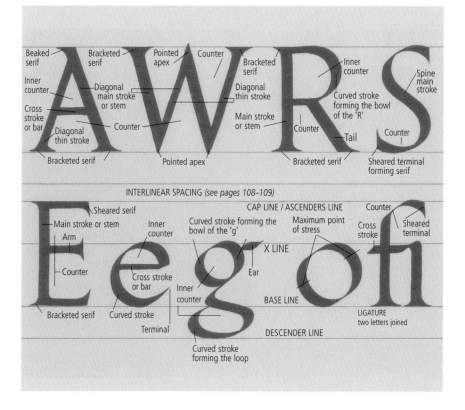

Beaked serif
Bracketed serif
Pointed apex
Counter
Bracketed serif
Inner counter
Spine main stroke
Inner counter
Diagonal main stroke or stem
Diagonal thin stroke
Curved stroke forming the bowl of the 'R'
Cross stroke or bar
Main stroke or stem
Counter
Diagonal thin stroke
Counter
Tail
Counter
Bracketed serif
Pointed apex
Bracketed serif
Sheared terminal forming serif

INTERLINEAR SPACING *(see pages 108–109)*

Sheared serif
CAP LINE / ASCENDERS LINE
Counter
Main stroke or stem
Inner counter
Curved stroke forming the bowl of the 'g'
Maximum point of stress
Cross stroke
Sheared terminal
Arm
X LINE
Counter
Cross stroke or bar
Ear
Inner counter
BASE LINE
Bracketed serif
Curved stroke
LIGATURE two letters joined
Terminal
DESCENDER LINE
Curved stroke forming the loop

What does the nib width mean and why is it important?

Nib width is the measurement of the width of the nib – in other words, the width of the writing point (or chisel shape).

Nib width is important because it determines the letter height – or the x-height as it is known *(see page 43)*. Letter height is measured in nib widths of your chosen nib size. The size of the nib and the number of nib widths determine the density (or weight) of the script. There are recommended letter heights for each script based on historical examples. It is advisable to gain experience with these scripts before exploring alternatives.

How do I make a ladder or steps to use the nib width for pencil guidelines?

A ladder or a chequerboard (or steps or a staircase) is a set of squares made by a pen at its full width. A ladder of nib widths will be your guide to how far apart to rule your lines for writing. The alphabets in this book all have a ladder pattern to indicate how many widths of the nib were measured to get the height of those letters.

If you create your own ladder pattern to make the same number of squares and rule your lines accordingly, your letters should come out with the same weight characteristics as the one you are copying, irrespective of the size of your pen nib.

Making a a ladder allows you to check you have not overlapped, by putting your pen in the white gap to see if you have room. If you make steps instead, ensure you double check them for overlapping.

MAKING A LADDER

1 The full width of the nib must be used to mark accurately multiples of the nib width. You may have to practise this several times to get precise marks. Make several ladders and measure them all to get an average. Check that you have not overlapped or left gaps.

2 Measure carefully with a ruler to the number of nib widths you know you need for the style you are writing *(right)* or, if you prefer, use a pair of dividers *(below)*.

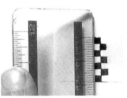

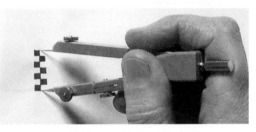

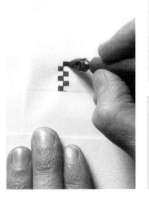

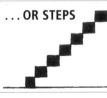

... OR STEPS Make steps (or a staircase) instead of a ladder if you find this easier.

What is the x-height?

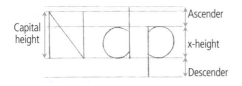

The x-height is the height of the main part, or body, of the letter – excluding the ascenders and descenders *(left)*. For example, in the word 'won', the bottom of the letters is the baseline and the top of the letters is the x-height.

What are ascenders and descenders?

Ascenders are the parts of a letterform that extend above the x-height *(right)*. For example, in the word 'fragmented', the tops of the 'f', 't', and 'd' are the ascenders. Descenders extend below the baseline. In the word 'overlap', the bottom of the letter 'p' is the descender.

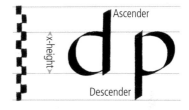

What is the cap height?

Cap height is the term that applies to the height of a capital letter, as opposed to the height of the body of a lower-case letter. This illustration uses the ladder (or chequerboard) to show the cap height of an Italic 'A'.

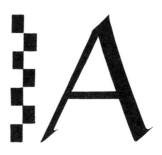

What is the pen angle and why is it important?

Pen angle is the angle at which you hold your nib in relation to the writing line (or baseline) and it affects the thickness of your stroke. The pen angle, in combination with the stroke direction, determines how thick or thin a stroke will be, as shown *(below)*. The pen angle is important because it is the angle that determines the weight of each stroke and the stress of the round letters. Because the angle is maintained from letter to letter, with the exception of one or two strokes, a certain quality and rhythm is created throughout the letterforms.

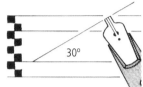

Therefore a style that is formed with the nib angle at 30° to the writing line will have a different visual appearance than that lettered at 45°.

When the pen angle is 30°, a vertical stroke will only be as wide as the image the nib will make at that angle and not equivalent to the full nib width. In a round

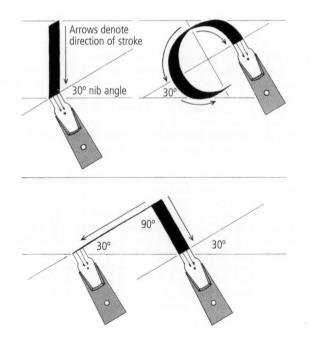

Arrows denote direction of stroke

30° nib angle

30°

90°

30°

30°

letterform, there is a point at which the whole of the nib width is used due to the pen travelling in a semicircle.

The maximum width of stroke – 'the stress' – will be exactly 90° to the thinnest stroke, which is fortunate for the round letterforms because, if the type of tool used did not produce this automatically, round letterforms would appear thinner than vertical ones of the same weight. Indeed, when letterforms are freely constructed with a pencil and filled in with a brush, compensation has to be made to the curved thick strokes, increasing them in weight to give an optical balance with straight strokes.

Why are the weight and direction of the stroke relevant?

The weight of stroke is determined by the angle of the pen and the direction of travel. Diagonal strokes will vary in weight depending on the direction of the stroke. Strokes made from the top left to bottom right are thicker than those formed top right to bottom left. Horizontal strokes are of a uniform width.

These variations are acceptable in pen lettering and they give the forms their characteristic thick-and-thin appearance. The alphabet is constructed from common vertical, horizontal, diagonal and curved strokes. Letterforms within the alphabet have common likenesses and, although there are twenty-six characters, the strokes that are repeated within the capitals and lower-case are frequent. This repetition makes the task easier: once the basic strokes used in letter construction are mastered, the forming of individual letters is relatively simple. The ability to produce the strokes with confidence comes from practising them on layout paper.

Should I lift the pen after each stroke?

Yes, unlike handwriting, where the pen is lifted from the paper only occasionally between words or necessary breaks in form, calligraphic lettering dictates that the pen is lifted after each stroke. It is the combination of strokes that creates the letterforms. The pen is nearly always used with a pulling action towards the letterer. Horizontal strokes are made from left to right. The nib should glide across the sheet. Don't be afraid to apply pressure – you will not break the nib and you will be able to achieve a more consistent stroke.

Are there exercises I could do to familiarise myself with 0° and 30° pen angles?

Yes, the exercises illustrated below (and in the following question) will help you to develop your skills in producing consistent strokes at accurate angles. You need to practise holding the pen at a constant angle to achieve these thick and thin strokes.

Use a protractor to help you establish the pen angles on your practice sheet. Carefully copy the strokes shown here, checking your writing against the examples and making corrections to them where necessary.

PEN ANGLES: 0° and 30°

 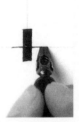

0° Establish the angle. **0°** Downward vertical pull. **0°** Left-to-right horizontal. **0°** Vertical and horizontal.

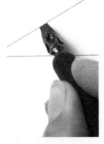 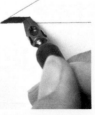

30° Establish the angle. **30°** Downward vertical. **30°** Left-to-right horizontal. **30°** Combined vertical and horizontal.

Are there exercises for 45° and 90° pen angles?

PEN ANGLES: 45° and 90°

45° Establish the angle.

45° Downward vertical.

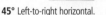

45° Left-to-right horizontal.

45° Vertical and horizontal.

90° Establish the angle.

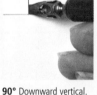

90° Downward vertical.

90° Left-to-right horizontal.

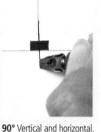

90° Vertical and horizontal.

EXPERT TIP

To achieve a clean-edged stroke you need to make sure both edges of the nib are in contact with the paper. If you have a ragged edge along one side of the stroke (far right) it may indicate you are applying uneven pressure when you write. In this case, more pressure is being applied to the right side of the pen than the left.

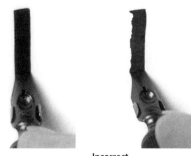

Correct **Incorrect**

What is the double-pencil technique?

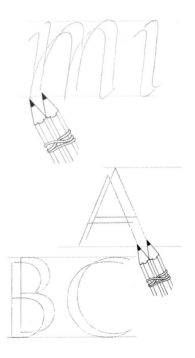

This is a very good technique for learning about the 'thicks and thins' that are made using a broad-edged pen. The technique also helps with learning to apply equal pressure. It consists of attaching two pencils together *(right)* and forming letters with them. The imaginary line that connects the two pencil points acts as the pen nib.

Make your own double pencils by binding together two HB pencils with a rubber band or masking tape. The points can be brought closer by shaving one side of each pencil with a sharp craft knife – keeping the cut areas level and not exposing the lead – before binding them firmly using masking tape with the points aligned. (For left-handers, the right point of the pencil should be slightly higher.)

To write accurate calligraphy strokes with a nib you have to keep its entire edge consistently in contact with the paper. This can feel awkward at first and it may help to spend time practising with a double pencil whose twin points produce the same effect as the edged nib with an outline form *(below)*.

MAKING LOWER-CASE LETTERS

The two pencil points represent the edge of a broad pen and are aligned at a 45° angle. Follow the example shown *(right)* and try making an alphabet of lower-case letters using this technique. It will help you understand how the broad-edged pen works.

MAKING CAPITAL LETTERS

Continuing to hold the double pencils so that the imaginary line between the two points acts like the pen nib, try making the upper-case letters as shown *(right)*.

How can the double-pencil technique be used for drawing letters?

Versals and Roman caps are often drawn and painted, rather than made 'off the pen' and the double pencil technique can provide a good base for drawing these letters. Imagine the red lines in the 'Q' shown here are your pencil lines created using the double pencil technique. You then ink over the pencil lines using a crow quill or other fine-point pen, creating an outline for the letter.

Then using a brush, you fill in between the outlines with ink or paint, creating a drawn letter, as shown in the final black 'Q'.

Can the double-pencil technique be used for flourishes?

Yes, the same principles apply in making flourishes with the double-pencil technique as making letters with the double pencil – that is, the pencil points represent the two 'corners' of the broad-edged pen. Practising with double pencils is a good way to improve fluidity in your flourishes *(below left)*. Remember too, that flourishes should remind you of ribbons, turning and twisting with soft curves *(below right)*. If the curves become square or angular, then some of the movement and flow of the flourishes will be diminished.

What are broad-edged pens with multiple points used for?

Broad-edged pens with distinctively separate nib points are used to create 'striped' strokes. Two-prong and five-prong pens are shown here *(right)*. These type of pens were originally designed to facilitate writing musical notes, but are now used for decorative effects. The striped strokes can stand alone as a decorative element, or they can be filled in with gold or a contrasting colour.

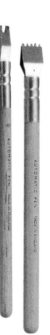

Left: The letters (from left to right in photo) *have been written using a three-prong nib that creates a thin-thick-thin pattern; a five-prong nib that produces five thin strokes with one pen stroke; and a two-prong nib that creates a thick and thin stroke.*

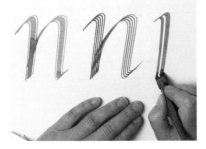

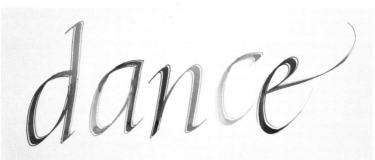

Above: *Try another interesting technique by loading different colours of paint into your pen nib as you letter. This method produces a gradual change in colour that creates very lively letters.*

Why does my ink skip and my pen feel dry? What can be be done to prevent this from happening?

There are four main reasons for your pen to feel 'dry'; that is, not allowing the ink to flow smoothly.

1 New pens are often very temperamental and feel scratchy until they are broken in. When using a new pen, it is especially important to get the ink flowing smoothly before attempting any writing. Moderate pressure on the nib and short practise strokes on scrap paper help to get the ink flowing.

2 If the reservoir is fitted too tightly, it will impede the ink's flow. Check that the reservoir is in contact with the pen, but not fitting so tightly that it separates the two prongs of the nib *(see page 12)*. When the pen is not in contact with the paper, the two prongs should be touching. If this is not the case, the reservoir may be too tight. Also, if the reservoir point is not touching the metal pen, the ink will not flow from the reservoir to the pen.

3 If you are using gouache, rather than ink or acrylic colour, the consistency may be too thick or too thin. Gouache is used because of its opaque colour and is made from pigment. If the pigment pieces are too large and/or not properly mixed with distilled water, they will block the flow of colour through the pen. The same resulting 'dry' feel can come from too much or too little water mixed with the gouache. Experiment with varying amounts of water and gouache to get the proper consistency.

4 The nib is creating uneven edges. Keep the nib in complete contact with the paper to avoid writing with ragged edges. Be sure to apply even, consistent pressure to the nib while writing.

SPARSE INK FLOW

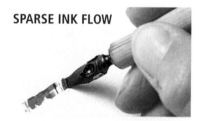

You may not be pressing hard enough. Check that the fit of the reservoir is not too tight and that it is not too far from the edge of the nib.

CORRECT INK FLOW

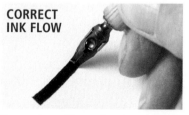

The pen is working well and produces a dense and sharp-edged stroke.

CHAPTER
4

Calligraphy Styles

Which script should I use?

With so many scripts to select from, it can be difficult to make a choice. Personal preference, the purpose of a piece and the meaning of the words will affect your decision. Gothic, for example, is difficult to read so would be an unwise choice for an urgent notice.

It is usually best to confine yourself to one or two related styles in any one piece of work. Several variations of the same style are more likely to unify a piece of work than the same number of unrelated styles.

You need to decide first if the project is formal or fun. Some scripts are more versatile than others – for example, with its many variations, Italic can be made to suit almost any occasion. If the project is formal – a certificate, for example – dignified, regular letterforms may be called for, like Roman capitals, Versals, Formal Italic or some Uncials. The more restrained versions of Copperplate, decorative elements or a flourished initial letter could be included for visual interest. The summary of the hands and the samples shown *(right)* provide a quick reference to the scripts that are covered in the following pages.

Above: *This is an example of a very formal style of script lettering. It would not be effective in a light-hearted invitation to a casual birthday party, but would be perfectly at home on a traditional wedding invitation.*

Roman capitals – classical; timeless quality.

Uncials and Half Uncials – these are associated with Ireland, Scotland and Northern England in the early Christian era. Narrower Half Uncials are an Anglo-Saxon form.

Decorative Versals – the 'Lombardic' versions traditionally are used as initial letters only and go with Gothic text.

Plainer Versals are more like Roman capitals and so have broader associations.

Carolingian – an elegant hand with French connections.

Foundational – a modern interpretation of the tenth century, late-Carolingian style: it is mainly used as a formal, contemporary hand.

Gothic – German; many German calligraphers still use free-form versions, but the highly decorative kinds have medieval associations.

Bâtarde – late medieval French; a more cursive form of Gothic.

Italic – from the Italian Renaissance; this style has become the most popular hand for present-day use owing to its versatility.

Copperplate – from the seventeenth and eighteenth centuries; the most ornate decorations are associated with Victorian England, which combined them with Gothic forms.

Roman capitals
ABCDEFGHIJKLMN

Uncials and Half Uncials
ABCDEFGHIJKLMN

Decorative Versals
abcdefgghijklm

Plainer Versals
ABCDEFGHIJKLM

Carolingian
abcdefghijklmnopqr

Foundational
abcdefghijklmn

Gothic
abcdefghijklmnopq

Bâtarde
abcdefghijkllmnn

Italic
abcdefghijklmnopqrst

Copperplate
ABCDEFGHI

What do Roman capitals look like?

The structure of Roman capitals is based on strict geometric models – mainly on squares and circles. This letterform has survived relatively unchanged for 2,000 years, and is still perfect for important titles, headings and signs, by themselves or combined with other hands.

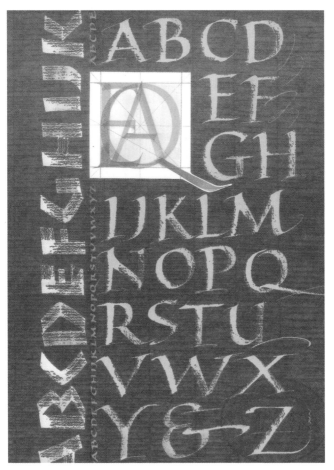

Above: *Carefully proportioned Roman capitals (in the square of this example) are overlaid to show their geometric relationships: these provide a contrast to the three more freely written alphabets.*

How do I write in the Roman style?

Holding your pen at a 30° angle, as shown in the illustration below, make the strokes for the letters following the blue directional arrows. If you have got it right, 'T' should have a thinner horizontal stroke compared with its vertical and 'O' should have the thinnest parts at 11 and 5 o'clock. The exceptions to the 30° angle are to flatten the pen to get a thicker diagonal on 'Z' and to steepen the pen to get a thinner stroke for the first vertical of 'M' and first and last of 'N'.

A B C D E F G

H I J K L M N O P

Q R S T U V W

X Y Z &!?; ÈÜÉ

1 2 3 4 5 6 7 8 9 0

Can I make my Roman capitals look heavier?

Yes, by changing the x-height from 7 to 5, your letters will look heavier. As it is freely written, make sure you do not sacrifice good letterforms when attempting to loosen up in this way.

DIFFICILE EST,
VERUM HOC

ABCDEFGHIJKLMN

OPQRSTUVWXYZ

&!?;ĒÜÉ 30°

Can I make my Roman capitals look lighter?

Yes, by increasing the x-height from 7 to 14, your letters will look much lighter in weight. This style can show up any hesitation. Use a small nib, and take care how you blend the joints between strokes.

UM HOC QUA LUB
LUBET EFFICIAS·D
CIAS·DIFFICILE EST

ABCDEFGHIJKLM

OPQRSTUVWXYZ

&!?;ĒÜÉ 0° 30°

What does Uncial lettering look like?

The Uncial style was developed from Roman capitals, but with a shallower pen angle and only 4 nib widths high. It is sturdy and round, with some Greek-looking letters such as 'A' and 'M'. Note how the stroke of the 'A' is different from the Roman capital version and this shows how it has evolved, through haste, into a shape that fortells its lower-case descendents (compare it with the 'A' in Carolingian). Uncials appeared in the fourth century and remained an important book hand until the eighth century; in the seventh to ninth centuries more complex versions evolved, with a flatter pen angle and requiring complex pen manipulation.

Above: *This example shows characteristics of both Uncials and the modified tenth-century style, but the overall effect is of an Uncial script.*

How do I write in the Uncial style?

Holding your pen at a 25° angle, make the strokes for the letters following the blue directional arrows. Check that you are keeping all the letters wide enough. Spacing between the letters of this rotund hand requires some special attention. Each letter should be able to 'breathe'. Use this angled version *(below)* for modern and historic work where a less formal effect is wanted.

Can I make my Uncial letters look heavier?

By decreasing the x-height, your alphabet will look heavier. Only 2½ nib widths high makes your Uncial letters look very dense. They are upright with open, rounded shapes made by using a shallow pen angle.

IFFICILE EST VERUM hOC

UA LUBET EFFICIAS DIFFI

ILE EST VERUM hOC QUA

†ABCDEFGhIJKLM N
OPQRSTUVWXYZ
ß &!?;ĕŭé 25°

Can I make my Uncials letters look lighter?

By increasing the x-height, your letters will look more lightweight. Look at the difference by changing the x-height from 4 to 5.

'FICILE EST VERUM

C QUX LUBET EFFICIXS

'FICILE EST VERUM

ɜ XBCDEFGhIJKLM N
OPQRSTUVWXYZ
ß &!?;ĕŭé 25°

What does Half Uncial lettering look like?

Half Uncials have a very rounded, curvy alphabet that stands on its own as a complete alphabet. This style evolved alongside Uncials between the seventh and eleventh centuries, some versions having quite pronounced ascenders and descenders, showing the first sign of a lower-case development.

Above: *The rounded nature of Half Uncials lends itself to a compact design, inviting play with colour in the shapes between letters. In this example, an automatic pen has been used on textured watercolour paper in designers' gouaches, with patches of gold leaf added.*

How do I write in the Half Uncial style?

Holding your pen at a 5° angle, as shown, make the strokes for the letters following the directional arrows. Hold the pen very flat to make thick verticals and thin tops and bottoms of curved letters.

The wedge-shaped serifs add weight to compensate for that thinness; make them as a separate curved stroke and blend carefully into the stem. Keep the ascenders, where there are any, shallow.

Can I make my Half Uncial letters look heavier?

Yes, by decreasing the x-height, your letters will look heavier. This example has been written at 3 nib widths and with wedge serifs. The wedges of 'D' and 'T' require some pen manipulation.

efficias·difficile es
verum hoc qua lu

?aδçcɒeꜰꝫghıɉkʟm
ɴopqʀ걚ꜱꞇuvɯxyz
ββ!?;ĕüé 5°

Can I make my Half Uncial letters look lighter?

If the x-height is increased from 4 to 6, your Half Uncial letters will look more lightweight. This example has been written with 6 nib widths, curved serifs and branching arches. Keep letters open and matching in width.

difficile est verum h
qua lubet efficias·t

;abcɒeꜰgghıɉkʟm
ɴopqʀ걚ꜱꞇuvɯxyyz
ββ!?;ĕüé 20°

What does Carolingian lettering look like?

Carolingian lettering was a ninth- to tenth-century standard book hand. It was a style that was pleasant to read and evolved in the court of King Charlemagne. Carolingian letters are rounded and based on an extended 'o' shape. The interlinear space is large (almost three times the x-height of a letter), giving an open, flowing letterform across the page. It is used today as a book hand.

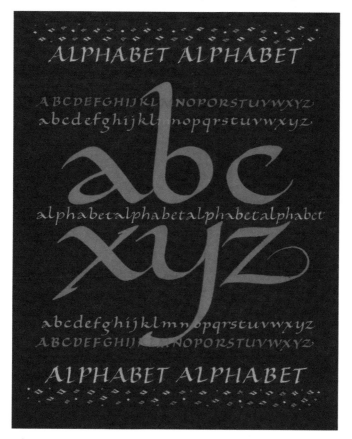

Above: *A simple Carolingian alphabetic design with an emphasis on letter and colour harmony. It is written in gouache on black, pastel paper. The capitals on the top and bottom are in gold gouache to create contrast.*

How do I write in the Carolingian style?

Holding your pen at a 30° angle, as shown, make the strokes for the letters following the blue directional arrows. The modern capitals here are sloped Roman capitals written at 6 nib widths height. Note the springing arches at the top of the 'B', 'D','P' and 'R' to relate to the minuscule (lower-case) arches.

Can I make my Carolingian letters look heavier?

By decreasing the x-height, your letters will look heavier. Look at the example below and notice how different the letters look by changing the x-height from 4 to 3½.

anbncndnenfngnhninjnknl
nmnonpnqnrsntnunvnwnx
ynzanbncndnenfngnhinjn
nlmnmonpnqnrsntnunv

r abcdefghijklmnopq
rstuvwxyz Bl?;ёüé&

30°

Can I make my Carolingian letters look lighter?

By increasing the x-height, the letters will appear more lightweight. You should write with a small nib. This variation is based on an extended 'o'. It gives a delicate, open feel with an emphasis on the heavier ascenders.

anbncndnenfngnhninjnknln

nonpnqnrnsntnunvnwnxnyr

abcdefghijklmnopqr
stuvwxyz B&!?; ёüé

30°

What does Versal lettering look like?

Versals are capital letters and are built up with pen-made compound strokes. The finest examples of this hand are found in ninth- to tenth-century manuscripts, where they are used as headings or to denote beginnings of verses, usually in red or blue. Today they can be used as complete text.

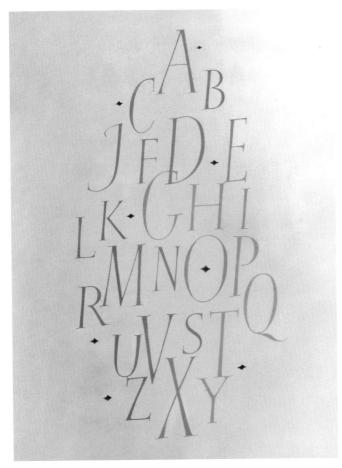

Above: *These elegant Versal letters were drawn in red and yellow gouache, on a background wash of coloured acrylic ink that gives a sealed surface on which to write.*

How do I create Versal letters?

Using a variety of pen angles, as shown, make the strokes for the following letters using the blue directional arrows. Three strokes of the pen held horizontally (0°) make the letter stem. Curved areas are made of three strokes but with the pen held at a slight angle. The stems are slightly 'waisted' for elegance. The letter structures closely follow the classical Roman letters. On heavier forms the letters can be outlined with pen and painted with colour.

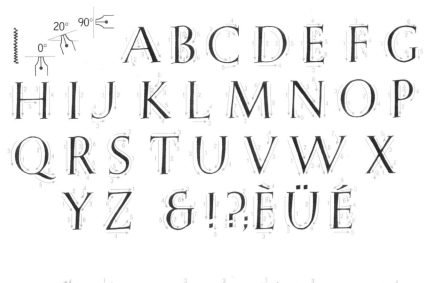

In the Versal alphabet, how are the two separate strokes made and then filled with ink?

The unusual feature of Versal capitals is that they are built-up, not written letters. Most of the strokes are formed in the same way, whether they are curved or straight. As a guide to height, base the letter on eight to ten times the width of the letter's stem. The inner strokes are drawn first to ensure that the counter shape is the correct proportion *(below)*.

A metal nib, a fine pointed brush or quill can be used to construct them – the instrument is manipulated at various angles to achieve a balance of thin and thick strokes.

1 In this Versal capital, the inner stroke is drawn first to establish the shape of the counter, and then the outer stroke is drawn. (On straight downstrokes, the stroke is slightly waisted in the middle.)

2 The two middle cross strokes start at the width of the nib and are splayed in the two flaring strokes at the end to produce a wedge shape.

3 The enclosing downstroke is the next stroke to be drawn. These hairline strokes should be lightly drawn with the pen held at a 90° angle to the paper.

4 The skeleton lettering is filled in with a single stroke. It is also possible to do the filling in with a fine sable brush.

Can Versal capitals be made to look lighter?

Yes, by increasing the x-height. Draw with three pen strokes of a small nib at 24 nib widths height, with hairline serifs. Note the compressed shape of the 'D', 'C','G','O' and 'Q'.

FICILE EST VERUM HOC
LUBET EFFICIAS DOCIL
ST VERUM HOC QUA LUB

ABCDEFGHIJKLMNO
PQRSTUVWXYZ
&!?.EÜE 0° 20° 90°

What are Lombardic capitals?

Lombardic capitals are a variation of Versal capitals. They are based on a twelfth-century Versal. They are used as the beginning of decorative letters and used singly. Draw with a small nib and 'flood in' letter shape with colour.

LE EST VERUM
UA LUBET OF
S DIFFICILE ES

ABCDEFGHIJK
LMNOPQRSTUV
WXYZ&!?.; EÜE 0° 20° 90°

What does Gothic lettering look like?

Gothic lettering has dense, angular strokes and diamond heads and feet. With narrow counters (1½ nib widths), it is very textural and difficult to read. The Gothic style evolved from the Carolingian minuscule and by the thirteenth century it was well established as a prestigious book hand, continuing in its many forms until the sixteenth century.

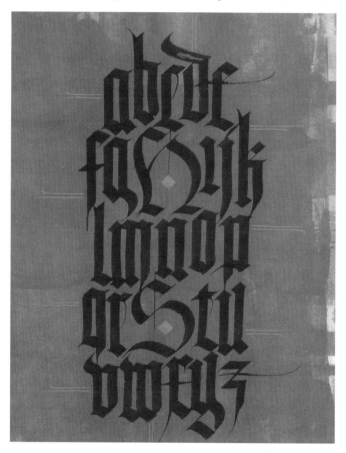

Above: *This is an example of Gothic alphabet in black Chinese stick ink written on a red-rollered background. An innovative contrast and use of space is created by the larger lower-case 'h' and 's', with diamond inserts in yellow ochre gouache.*

How do I write in a Gothic style?

Holding your pen at a 40° angle as shown, make the strokes for the letters following the blue directional arrows. Letters are created with many pen lifts and manipulated angles. Gothic lettering is usually written at an x-height of 4 to 5 nib widths.

Are there variations for Gothic capital letters?

Yes, there are many variations – here is one from the fifteenth century.

Can I make my Gothic letters look heavier?

By changing pen angle and x-height, the weight of the letters changes. See what happens when you go from 5 to 4 nib widths for the x-height and flatten out the pen angle. This rounded letterform is a less angular, more open style of Gothic lettering.

nbncnɔnenfngn
hnijnknonlomno

ːabcɔdefghijklmn
opqrʒstuvuɪɾyzʒ
ß&!?;ëüé

0° 20° 30°

Can I make my Gothic letters look lighter?

Yes, by increasing the x-height from 5 to 6 nib widths, your alphabet will look lighter. This lightweight, fractured example has many curved strokes and creates exciting text. It can be used as a display script.

anbncnɔnenfnɪ

ːabcɔefghiijklmnopq
rʃtuvwɾyʒßɡ?l;éüé

40°

What does Bâtarde lettering look like?

Bâtarde lettering is a Gothic cursive hand – a more freely written everyday style than the formal Gothic hand. Several versions of some of the letters have been copied faithfully from French manuscripts of the thirteenth to sixteenth centuries.

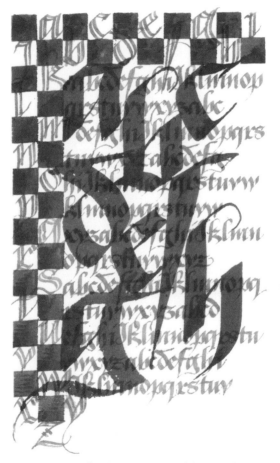

Above: *Here is a very fine historic version of the Bâtarde style. Cream-coloured, handmade paper sets off this design of green and brown in an interplay of overlays and contrasting sizes, emphasising the textural effects of this attractive hand.*

How do I write in the Bâtarde style?

Holding your pen at a 35° pen angle, as shown, make the strokes for the letters following the blue directional arrows.

The lower-case is only 3 nib widths high and has sharply pointed arches and needs a lot of pen twisting. Some strokes may be difficult with a modern nib as they were invented for the more flexible quill pen. Drag the ink along the corner of the nib to make the hairline strokes; twist the pen on the downward stoke of 'F' and 'p' to get the tapering point. Bâtarde capitals tend to vary a good deal in height.

Can I make my Bâtarde letters look heavier?

By changing your pen angle from 35° to 40° or 45° and by applying more pressure on the downstrokes, you will 'swell' the thickness of the strokes, making the alphabet look heavier.

anbncndnenj frgnhninjnk

ſ a b c d e f g h i j k l l m n o p q r s t u v w x y z ß & !?; ēüé 40° 45°

Can I make my Bâtarde letters look lighter?

Yes, by increasing the the x-height. Look at this example where the x-height was simply increased from 3 to 5 nib widths. Also note the curved tops to ascenders; the plain 'y' form; and that the 'f' vertical is given weight with an extra stroke.

inbncndnenfrgnh ihninjnknlnmnon

ſ a b c d e f g h i j k l m n o p q r s t u v v w x y y z ß ſ !?; ēüé 40° 45°

What does Italic lettering look like?

Based on an oval 'o', the compressed letterforms of formal Italic have springing arches (branching two-thirds up the stem). Italic evolved in the early fifteenth century during the Italian Renaissance; a cursive hand developed from the humanist minuscules. The origins of both letterforms lie in the ninth- tenth-century Carolingian scripts. Italic capitals, based on Roman capitals, are compressed and sloped. Italic is the most versatile hand to the calligrapher and can be used for formal scrolls and certificates or for more expressive forms of calligraphy.

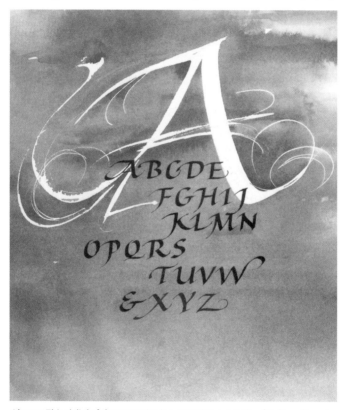

Above: *This delightful manuscript is a stunning example of Italic calligraphy. An automatic pen and masking fluid were used for the 'A' here and fine lines were created with the pen corner. The 'swash' capitals are written in gouache on an acrylic ink background wash.*

How do I write in the Italic style?

Holding your pen at a 35–45° angle, as shown, make the strokes for the letters following the blue directional arrows. In this version of the Italic hand, there is less pen lifting than with other versions. There are many variations to the Italic hand and to achieve a more angular appearance when writing in this style, keep the pen angle at 45° and lift your pen between each stroke. By stopping and lifting your pen between strokes there will be less 'rounding' of the corners of letters. The alphabet shown below lends itself well to a cursive style of casual handwriting.

35°-45°

a b c d e f g h i j k
l m n o p q r s t u v
w x y z ß & ! ? ; ĕ ŭ é

A B C D E F G H I J K
L M N O P Q R S T U V
W X Y Z

1 2 3 4 5 6 7 8 9 0

Can I make my Italic letters look heavier?

Yes, by changing the pen angle to 30°, the weight of the letters changes. If you decrease your x-height from 5 to 4, it creates a denser letterform, making the letters look heavier. The 30° pen angle and expanded letters give a rounded squat shape, similar to Carolingian.

anbncdnenfngnhninjnkn
nonpnqnrnsntnunvnwnx
ynznanbncndnenfngnh

abcdefghijklmno
pqrstuvwxyz ß & !
?; ĕüé 30°

Can I make my Italic letters look lighter?

Yes, the Italic letters can be made to look lighter by increasing the x-height. Look at what happens when you go from 5 nib widths to 8. A pen angle of 30° will produce a rounder, wider letterform. Eight nib widths x-height makes it lightweight and spacious. Note the small hook serifs on this sample.

inbncndnenfngn
ininjknlnmnonp

abcdefghijklmnopqrs
tuvwxyz ß!?,& ĕüé 30°

What does Copperplate lettering look like?

Copperplate, also known as English Roundhand, is oval in shape with a steep slope and a flourished style that has been developed from Italic as an engraver's script from the seventeenth century. This script is used for formal occasions and for projects that allow its decorative aspect to be shown to advantage.

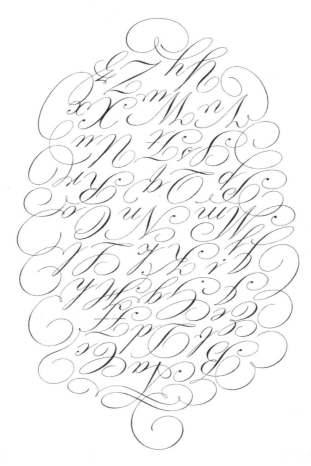

Above: *The complexity of this Copperplate lettering design becomes increasingly apparent as you follow some of the decorative outer flourishes and find where they originate.*

How do I write in the Copperplate style?

Using a pointed pen *(see page 14)*, make the strokes for the letters following the blue directional arrows. You hold the special flexible pen totally differently from the broad-edged kind. Turn the paper and your hand so that the pen is directly in line (parallel) with the steep 55° writing slope. Pull down towards you while applying pressure for downstrokes and use very light pressure for the upward strokes.

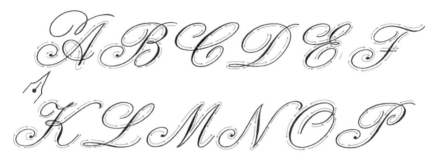

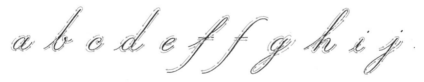

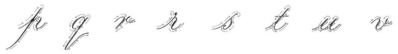

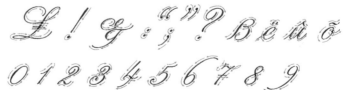

The ascenders and descenders are twice the x-height of the lower-case letters and the capitals are about the same height as the ascenders. Changing stroke direction often requires lifting the pen.

MAKING COPPERPLATE STROKES

1 This letter is being written with a fine pointed nib and begins with a hairline stroke with virtually no pressure on the nib so that it glides over the page. Gentle pressure is applied to the first downward stroke, which finishes with a square end.

2 The second vertical stroke is preceded by another fine hairline stroke. Observe where the hairline leaves the first vertical stroke. Notice the shape of the white space formed by the two strokes.

3 Unlike the first two vertical strokes, which finished with a square end, the final stroke curves around into a hairline. This hairline is usually extended and becomes the first stroke of the next letter.

Are there any variations in the Copperplate style?

Yes, but unlike the broad-edged pen styles the variations occur more by adding flourishes or changing the width of the letters. Because it is made with a pointed pen, the pen angle is not relevant. However, some nibs are more flexible than others, producing a wider stroke.

Look at the samples on these two pages for some ideas. The first example *(below)* shows how modest flourishes can keep a variation comparatively simple. As an added feature, the capitals in this sample have a pronounced dot at the left-hand edge of their flourish.

Aa Bb Cc Dd Ee Ff Gg Hh
Ii Jj Kk Ll Mm Nn Oo Pp
Qq Rr Ss Tt Uu Vv Ww Xx
Yy Zz ß & !?; è ü é

Heavyweight: This version is trickiest; weight is achieved by a double line and filling in. The weight allows 'B' and 'D' to have one joined flourish without letter distortion.

ianbmeufasxptr
mveiyxcwrjiolfqc

Aa Bb Cc Dd Ee Ff Gg Hh
Ii Jj Kk Ll Mm Nn Oo Pp
Qq Rr Ss Tt Uu Vv Ww Xx
Yy Zz ß & !?; è ü é

Medium weight: For this variation you need to make two strokes for the heavy lines if you cannot achieve them with pressure. The flourishes on the capitals are short, self-contained curls and the points of 'M' and 'N' are looped.

iwxcrwpoqnwstvn
ifnlvurwmyteuxiu

Aa Bb Cc Dd Ee Ff Gg Hh
Ii Jj Kk Ll Mm Nn Oo Pp
Qq Rr Ss Tt Uu Vv Ww Xx
Yy Zz ß ç !?; è ü é

Wider: In this sample, the letters are slightly more open laterally. It is a standard weight and the flourishes are more open. The dots are small but make an attractive pattern.

abceuomgtuswxpiy
mwgtruilxzbnyspu

Aa Bb Cc Dd Ee Ff Gg Hh
Ii Jj Kk Ll Mm Nn Oo Pp
Qq Rr Ss Tt Uu Vv Ww Xx
Yy Zz ß ç !?; è ü é

What does Foundational lettering look like?

Foundational hand was invented by Edward Johnston (1872–1944). He based it on the study of ninth- and tenth-century manuscripts – in particular a Carolingian script. The modern Foundational hand *(see below)* is slightly different from the original manuscript and has formal characteristics. Calligraphers today have imposed rules on this hand to allow the script to be consistent.

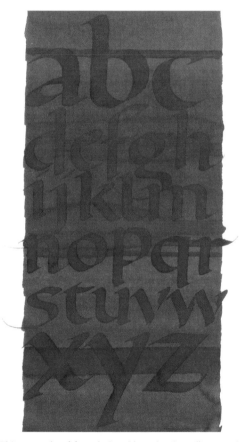

Above: *This example of foundational lettering is well proportioned and uses the lower-case alphabet with controlled hairline extensions to 'e', 'g', 'j' and 's'. It is written with an automatic pen and red ink on red ink background washes that give it vibrancy.*

How do I write in the Foundational style?

Holding your pen at a 30° angle, as shown, make the strokes for the letters following the blue directional arrows. Written upright at 4 nib widths x-height, at a constant pen angle of 30° (except diagonals), the letters are formed with frequent pen lifts, beginning and ending with small serifs. This gives the script its formal characteristics. Classical Roman capitals are used with this script – in the tenth century, the capitals would have been Uncials or Versals.

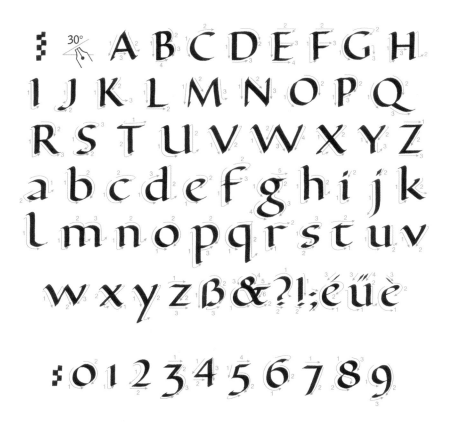

Can I make my Foundational letters look heavier?

Yes, by decreasing the x-height from 4 nib widths to 3, or even 2, the alphabet changes dramatically. This variation, shown in the alphabet examples *(right and below)*, has wedge serifs for 'h', 'm' and 'n'.

anbncndne
ngnhninjn

abcdefghijklmno
pqrstuvwxyz ß & ?!;
éűè

Left: *This example of heavier Foundational lettering is from an English manuscript of the late tenth century.*

Can I make my Foundational letters look lighter?

Yes, by increasing the x-height from 4 to 5, it becomes more lightweight. The 5 nib widths x-height with the slab serifs throughout give this variation elegance rather than strength.

anbncndnenfn
gnhninjnknln

⁊abcdefghijklmn
opqrstuvwxyzß
&?!:éüè 30° 45°

awakening
from winter's icy grip, the frozen earth thaws
revealing its emerald cover

Above: *A sample of lighter Foundational lettering that combines large- and small-scale writing. The main word is written with a Mitchell No. 1 nib and the subsidiary text is written with a No. 3 nib.*

Flourishes and Swashes

What are flourishes and swashes?

Flourishes and swashes are very similar, but a flourish is a pen-made, decorative addition to a letter whereas a swash is an elaborate flourish added to a capital letter. Although the term 'flourishes' suggests flamboyance, they can range from subtle stroke extensions to elaborate traceries of loops and lines. They can be a wonderful enhancement to calligraphic work, provided they are carefully matched to their context. Sign writing, certificates and commemorative inscriptions, diplomas and greetings cards are just some of the areas in which they can be used with a restrained or spirited effect.

Flourishes must appear to be an intrinsic part of the letter, not a contrived addition. They need to be written with flowing movement, speed, directness – and good pen control. In your enthusiasm for writing flourishes, it is easy to neglect the letter shapes themselves. These must be accurate if letter and flourish are to form a harmonious whole.

Finding creative ideas

Whether you find flourishes easy or not, you must first understand the principles of good flourish design. Remember that the choice of flourish depends on the design context and the purpose of the calligraphy. Begin by learning some basic flourish shapes, but also study the creative ideas of other calligraphers, past and present. Look for inspiration in the wonderful, imaginative flourishes of Renaissance calligraphers that you can find in illustrated books – and in the work of twentieth-century calligraphers who have developed innovative lettering for contemporary needs.

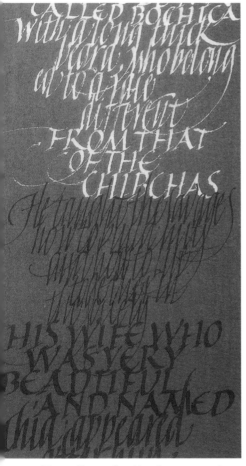

Above: *Elegant flourishes form a natural part of these freely written Italics.*

How do I create flourished capitals?

Flourished capitals are usually the first letterforms to be considered when learning flourish design because of their role in titles and at the beginnings of text. You can add flourishes to the entire capital alphabet with the aid of the four basic flourish types shown *(below)*. Each group begins with a simple flourish and progresses gradually to more complex and elaborate variations.

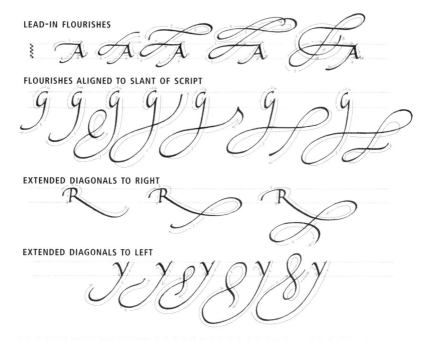

LEAD-IN FLOURISHES

FLOURISHES ALIGNED TO SLANT OF SCRIPT

EXTENDED DIAGONALS TO RIGHT

EXTENDED DIAGONALS TO LEFT

PRACTISING FLOURISHED CAPITALS

1 Rule lines 7mm (¼in) apart, the equivalent of 8 nib widths of a Mitchell No. 4 nib.
2 Use a pencil at first, so that your hand and arm are not restrained by the resistance of the broad nib against the paper. Loosen up with some large, sweeping movements, such as the tail on the 'R'. Be sure to let the pencil move lightly over the paper.

3 Copy flourishes from each group, in the order shown, until you have memorised them well enough to write without hesitation.
4 When you feel confident with your pencil, repeat the exercise with a No. 4 nib.
5 You may need to make several attempts at each flourish to produce flowing lines.

How do I create swash capitals?

Swash capitals are relatively simple flourished letters that are ideally suited to line beginnings – for instance, in poetry. The alphabet *(below)* provides a good starting point for beginners. To write these letters with both flow and control, copy the alphabet, following the stroke order and direction indicated.

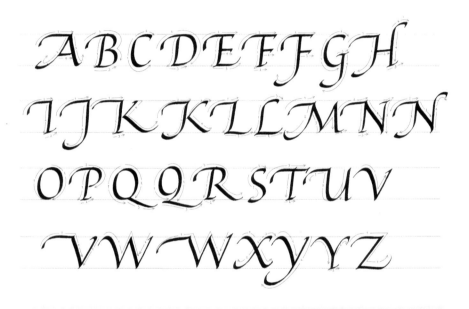

PRACTISING SWASH CAPITALS

1 Rule lines to a height of 8 nib widths of a Mitchell No. 2 nib.
2 Practise the capitals in alphabetical order, writing each letter several times before moving on to the next letter.

3 Take care with letter spacing, so that swashes do not overlap.
4 When you have gained in confidence, try writing some words with swash capitals in a text of your choice.

How do I create flourishes for lower-case Italic?

Flourish design for lower-case Italic follows the same principles as for capitals. There are two main directions in which the extension can travel. Practise flourishes for Italic minuscules *(below)*. You will find examples for 'y' and 'h', moving from a simple flourish through to more complex designs.

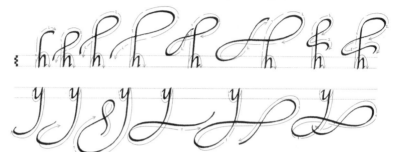

PRACTISING FLOURISHES FOR LOWER-CASE ITALIC

1 Rule lines 5mm (³⁄₁₆ in) apart, the correct x-height for a Mitchell No. 4 nib.
2 Practise each letter several times in pencil until you are familiar with the design.

3 Repeat the exercise using a Mitchell No. 4 nib, omitting any flourishes that are too difficult at first.
4 Make sure that the reservoir moves easily up and down the nib, or the ink will not flow easily.

Can you create flourishes on symbols?

Yes. Symbols other than standard letter-forms may also be flourished or written in unusual ways. An example is the sign for 'and', known as an ampersand.

An ampersand must harmonise with the script being written and you may find that a simple design suits the context better than a flamboyant one.

PRACTISING FLOURISHES ON AMPERSANDS

1 Rule lines to a height of 8 nib widths of a Mitchell No. 2 nib.
2 Practise each of the ampersands in turn, first on their own and then in context with an appropriate script.

TYPE 1

TYPE 2 TYPE 3

Are there guidelines to follow when creating flourishes and swashes?

Yes, flourishes should be carefully proportioned and must relate to, and not obscure, other parts of the text. Sometimes a flourished design may be complete in its own right. For a certificate, poster, title page, or dust jacket like the one shown here *(below)*, only a decorative heading or panel may be needed, with plenty of space all around it. This gives you more scope for flourishing.

1 Much of the success of flourishing comes from the detailed planning of the design. Here preliminary pencil roughs are sketched.

2 When first learning to design flourishes it may help to pencil the flourishes on to the simple letterforms written in ink.

3 Several different flourish designs are written using a Mitchell No. 2 nib. Each design is then considered within the context.

4 The final design is written in gouache, and a decorative border is added in gouache with a brush.

5 The finished piece shows how the flourishes balance the design, breaking into the top and bottom white space and guiding the reader's eye.

EXPERT TIP

Although flourishes look simple, they require a great deal of skill. Make sure the flow of the flourish is round and not angular – think of it as a ribbon flowing around the letters.

Can you give me some tips on incorporating flourishes into my work?

Here are two good examples. In this decorative piece of work *(below)*, carefully planned flourishes connect the spaces and carry the eye into the design. The panel *(right)*, produced as part of a corporate-identity programme, uses carefully considered flourishes at the top and bottom. These flowing strokes help to integrate the different elements in the overall design.

Does a flourish have to be a unique, spontaneous stroke?

A flourish can be unique and spontaneous, but doesn't have to be. Look at the sample shown *(above)*. The flourishes are used in a border-like fashion, very much in keeping with the constrained style of the Gothic lettering. Sometimes, a different pen is used for the flourish and the main lettering, as was done in this example.

Can flourishes be categorised as both traditional and contemporary?

Yes – and two good examples are on this page. The sample *(above)* with the Gothic lettering definitely has a traditional feel to its symmetrical, border-like flourish.

In contrast, the sample shown *(below left)* has a decidedly more contemporary look, as evidenced by the free-flowing strokes that create the flourishes. One flourish even turns into an exclamation mark! Even the colour conveys an image of contemporary style.

Can I experiment with my own designs?

Yes, but make sure you are familiar with some basic flourishes first. Planning in pencil will enable you to work faster and more freely. Write spontaneously, letting ideas flow and follow up with design refinements using a broad-nibbed pen.

EXPERT TIPS

Here are some tips for when you are improvising with flourishes and swashes.

✓ Spontaneous flourishes depend on knowledge and pen control.

✓ Write flourishes smoothly and rhythmically. Speed develops with practice.

✓ Write flourishes continuously. It is necessary to break them into component strokes only when writing them with a very large nib – and not always then.

✓ When straight lines and curves join, make sure the transition follows through in a fluid movement.

✓ Establish a sense of spaciousness around the letter. Over-close flourishes create a cramped design.

✓ Diagonal strokes are usually parallel. Do not write them too close together or the flourish will look heavy.

✓ Design and practise flourishes in pencil for uninhibited movement and speed.

✓ Practise with chisel-edged brushes or large chisel-edged felt-tip markers to loosen arm movement and encourage experimentation.

Christopher Haanes · F.S.S.I.

Kalligrafisk Design & Skriftkunst

Hesselberggt. 3 · N-0555

OSLO · NORWAY

Tel./fax.: 02-35 41 23

Selvst. næring nr. 309 909 19

Postgiro 0531 63 28611

Right: *The combination of flourished Italic with red type makes for a stylish, sophisticated image.*

CHAPTER

6

Composition and Layout

"At the end of that time I will ask you a riddle. If you guess it the bargain is ended. But if you cannot guess it you must be my servants through all eternity"

I WILL GIVE YOU SEVEN YEARS OF FREEDOM. "I," SAID THE DRAGON.

What is letter spacing?

Once you have lettered your first alphabet, you need to consider spacing the letters in order to produce words. This would be an easy task if all the character shapes were either straight sided or round, as then the same amount of space could be left between them. Unfortunately, the alphabet consists of many different-shaped characters; measuring the same amount of space between characters does not produce an aesthetically pleasing word. Instead, reliance must be placed on optical spacing and fine adjustments.

Letter spacing is one of the most difficult aspects of lettering. Calligraphy, sign-writing or using pre-cut letters or lettering proper (that is, with a brush on paper or board); all these forms of communication require good letter spacing if they are to achieve their aim of informing in a legible and attractive manner.

The characters of the alphabet can be divided into four main groups: straight-sided, rounded, open and oblique. Some fall into more than one group; for instance, the capital and lower-case 'C' are both rounded and open.

Guidelines for spacing

As a guideline, think of round letters as being close spaced and straight-sided letters as being the widest spaced. Consider these two groups. A vertical letter in its simplest form is the 'I' and a round letter the 'O'. If the combinations of 'IOOI' and 'OIIO' are looked at, the difference in spacing can be seen.

The top line lettered (below) is spaced mathematically; the second line optically. The difference is that optical spacing takes into account the nature of the 'O', with its round shape giving a greater amount of white area than a straight-sided letter. It is this counter-space that must be considered. The golden rule is not only to appreciate the shape of the

letters but also the white areas that they create around them. These are just as important as the forms themselves, and you can't commit yourself to a letterform without being concerned with the areas they create. Your aim is to produce even areas of white space between the letterforms. This will take some time to learn and experience only comes through a rational approach to spacing.

Evaluating space requirements

A letterform's space requirement must be evaluated before you commit your pen to paper in order for you to achieve a harmonious result. Often calligraphers use the HIOC combination of letters to experiment with spacing.

Shown here *(below)* are a combination of two straight letters next to each other ('H' and 'I'); a straight and round letter next to each other ('I' and 'O') and two round letters next to each other ('O' and 'C'). Observe the blue hash-lines and how the area they fill changes shape but not 'volume.' This is how visual balance in spacing is achieved. Also shown *(in the bottom row)* is the same technique using capital Italic letters.

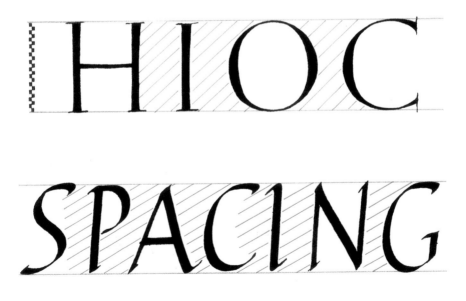

How do I work out the spacing between letters?

Once you have lettered your first two characters, you have set the criteria that will determine the spacing of all the letters that follow. If the first two characters are straight-sided, they should be lettered with sufficient space between them to accommodate the close spacing necessary for round letters that may follow (**1**). Without making this judgement prior to lettering, the rounded forms will be tightly spaced and may even touch each other if the first letters are very close. The reverse can be said for two rounded characters at the beginning of a word (**2**). If they are spaced too far apart, the end result will be an over-spaced word because the straight letters will require extra space to appear optically balanced with their rounded partners.

Open and oblique letterforms vary in the amount of space they require in accordance with the word construction. However, as a rule, open letters are fairly closely spaced because the open counter has to be taken into consideration (**3**).

Owing to the letter combinations, the word 'TALE' (**4**), for example is difficult to space. There are numerous other combinations for which it is almost impossible to achieve total harmony in the spacing and where it is necessary to resort to other methods, such as the forming of ligatures or the reduction of the length of stroke.

In the word 'TALE', the crossbar at the right of the 'T' overlaps the thin diagonal stroke of the 'A'. This is done to reduce the natural space made by both letters and will now set the optical standard for the remaining letters. In order to space the 'L', the area between the 'T' and 'A' must be evaluated and the same amount

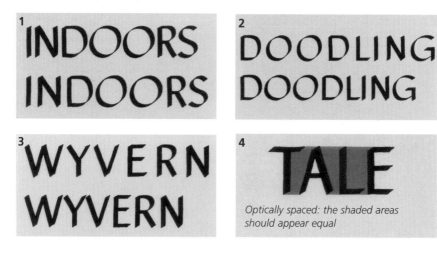

1 INDOORS
INDOORS

2 DOODLING
DOODLING

3 WYVERN
WYVERN

4 TALE
Optically spaced: the shaded areas should appear equal

of space must be left between the thick oblique stroke which forms the right of the 'A' and the vertical straight stroke of the 'L'. In order to space the 'E', cover up the 'T' with a piece of paper. This will allow you to concentrate on the positioning of the 'E' without being distracted by the 'T'. Letter the 'E' so that the space left between the 'L' and 'E' is equivalent in

area to that between the 'A' and 'L'. If a longer word required spacing, it would be necessary to cover up the previous letter in each case, so that only two letters are visible at any given time, while deciding on the position of the third. This spacing system described in this answer is known in calligraphy as the three-letter spacing method.

MAKING ADJUSTMENTS

This example of Roman sans serif lettering *(left)* shows how to adjust spacing correctly. In the left-hand column, the words have been lettered without minor adjustments so that the problems that these letter combinations create can be clearly seen. To achieve the evenly spaced words in the right-hand column these adjustments include reducing the arm of the 'r', undercutting diagonal strokes and substituting ligatures where required.

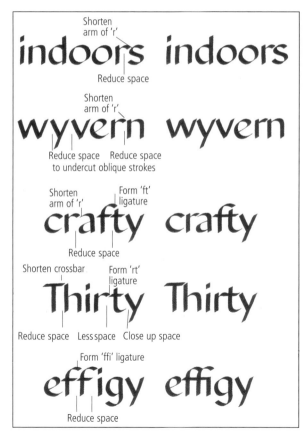

How much space should there be between words?

When you start working with a line of text rather than a single word, you need to think about word spacing. Word spacing is the amount of space left between one word and another. It is strongly linked with letter spacing – that is, if too much space is left between words the rhythm of the line is broken, leading to poor readability. The amount of space used between words must be consistent if continuity is to be achieved. Therefore it is necessary to have a unit of space that is regular throughout the line and a simple system to determine the amount of white space to be left.

Again, there is no mathematical answer for achieving even units of space, as the letterforms differ in shape. Word spacing must therefore also be based on visual judgement by using a capital 'I' for space between words in capitals and a lower-case 'i' for lower-case words. These 'i's are letter spaced between the words to give the same optical value. In effect, a complete spacing system has now been outlined *(see examples below)*.

The words in a line of text should be treated as a complete word. In the example, a capital 'I' has been inserted between the words and highlighted in red to illustrate the system. When a line of text is word spaced, the 'I' should be lettered using a carpenter's pencil that has been sharpened to a chisel edge the width of the pen nib, simulating the pen stroke width. After a line is completed, erase the pencil mark to give the finished result. Once you have become familiar with word spacing, there is no longer a need to use a pencil.

If you want to practise spacing words correctly, draw up guidelines on a layout sheet using the proportions for Roman sans serif. Letter the example using the method described above and compare your results with the samples *(below)*.

THEISPACINGITOIUSE

initheispacingiofiwords.

How do I combine large and small lettering?

Along with good letterforms, spacing and rhythm, it is important to develop a sense of scale by combining different sizes of writing successfully *(below)*. Combinations are generally used for contrast, but the sizes must harmonize and convey the text appropriately. Sizes should not be too similar, but there are no rules for such decisions: each text needs to be treated according to your own interpretation. A sense of what looks right in terms of text and layout develops with practice and by observing examples of well-designed calligraphy. You will find that analysing the decisions that have been made about scales of writing in the work of other calligraphers – past and present – is invaluable for your own work.

late summer
afternoon,
heavy storm
breaking
light mountain
rain, falling veil,
fading the land
into oblivion

How much space should there be between lines?

When lettering more than one line of text it sometimes becomes necessary to add extra space between lines. This is known as interlinear space. The main reason for this additional space is to prevent the descenders of one line from clashing with the ascenders of the line below. Even half a nib width of space

inserted between the lines can eliminate this problem (**1** and **2**).

The style of lettering used will affect the amount of space required. If the style has a large x-height with small ascenders and descenders, it will need more interlinear space than a style that has a small x-height with long ascenders and descenders.

1

Both legibility
and readability are
determined by
sensitive spacing.

2

Both legibility
and readability are
determined by
sensitive spacing.

In addition to considering the lettering style and the minimum interlinear spacing required, the calligrapher also needs to consider the overall design of the piece. Some documents, such as a formal wedding invitation, usually demand a great deal of interlinear spacing to convey visually the message of formality.

Other pieces might benefit from lettering that is 'stacked' with virtually no interlinear spacing to convey a message of strength and power.

As a general guide to the amount of interlinear space required, the space between x-heights should not be less than the x-height of the style being lettered.

LINE SPACING GUIDELINES

The distance between writing lines (interlinear space) is determined by the x-height of the letters *(see page 43)*. This is the height of the body of a lower-case (minuscule) letter, excluding ascenders and descenders (tops and tails on letters such as 'd' and 'p'). Sufficient space must be left between writing lines, however, to accommodate ascenders and descenders of letters without their becoming entangled.

A distance three times the x-height from the baseline to baseline is usually best for beginners when starting to use lower-case letters.

Writing line – x-height

Baseline to baseline – three times x-height

Interlinear space – twice x-height

What is a layout?

Layout is the arrangement of writing and design elements on the page and takes into account a number of variables.

Column width is one important aspect some styles are shown here *(below)*. The proportions of white space to text – that is, the widths of top, side and bottom margins – also need to be assessed in terms of both aesthetic preference and the work's function. Work that is presented flat may have any size of margin from minimal to extremely broad *(see pages 118–119)*.

Calligraphers may, however, apply aesthetic preferences in their layouts. A freely written, flamboyant word or phrase may seem more expansive and rhythmic if surrounded by white space, whereas small, fine writing in an open letterform may gain cohesiveness if allowed to create a mass of text that is both broad and deep.

Legibility is normally important. Between eight and twelve words per line are easily read. The number of words that fit obviously depends upon the style and size of the letterforms. Adjusting to five or six words per column is reasonable. If there are fewer words in a line, the text starts to seem jumpy; and a line longer than twelve words is tiring to read.

Paragraph format also affects layout and may be differentiated by putting an extra line space between paragraphs or by an indentation.

Left: *Double-page spreads with different styles of column widths.*

1 A page divided into two columns aligned at either side enables pictures to be inserted into the width of one column.

2 Two columns of text can be arranged around a central piece of ornamental writing and illustration.

3 The standard double-page layout has each outside margin equal to the central space between the blocks of text.

4 The single page shows the balance of a standard type page, with three sides equal and more space at the bottom.

What is a thumbnail?

A thumbnail is a small drawing that represents overall layout. There is very little, if any, detail. Thumbnails are a great tool for trying out several different layouts – see the samples *(opposite)* that show different alignments.

THUMBNAILS TO SHOW ALIGNMENTS

CENTRED The writing lines are balanced equally on either side of a central line (drawn faintly in pencil and erased after writing). This symmetrical layout is useful when balancing long and short lines. A centred layout is most suitable for poetry or short prose.

ALIGNED LEFT All writing lines begin from a straight vertical left margin. This gives a strong left edge and a softer right-hand effect. Avoid marked variations in line length and split words. This is a versatile layout, used for both poetry and prose.

ALIGNED RIGHT The lines are aligned vertically on the right. This is effective in giving a degree of tension to the design, although it takes practice to achieve accuracy of letter widths and spacing. This layout is often seen in short texts such as letterheads.

ASYMMETRICAL This is a layout that does not conform to an established alignment and yet maintains a sense of balance. A key feature is the non-alignment of most or all line beginnings or endings. This works well where a feeling of movement is appropriate.

JUSTIFIED Both right and left edges are vertically straight. Skill is needed to calculate word spacing to achieve this effect. Justified layouts produce a formal effect that is useful for prose work.

How do I centre text?

Using the same x-height (letter height) write out the text you want to centre on a piece of paper other than your final piece. When it's dry, mark its centre point.

By marking the centre of your finished piece, you can line up the two centre marks and know where to begin and end your line of text on the finished piece.

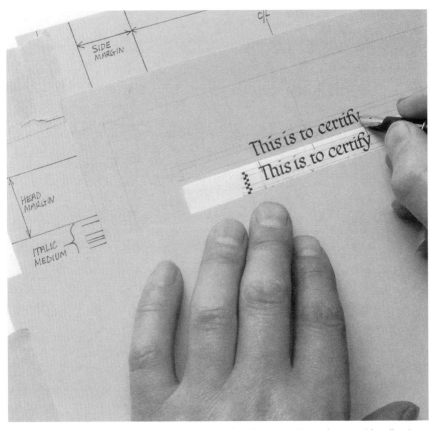

Above: *The same x-height and pen were used to letter the words on the white paper as will be used on the final piece. The lettering on the white paper is used as a guide, allowing the calligrapher to judge accurately the amount of space required for the text.*

Why are headings an important part of calligraphic work?

The way you treat a heading or title in a piece of work is an important factor in making a calligraphic design successful.

Headings have many roles. The word, or group of words, has to attract the attention of the viewer to both the whole work and to the title itself. It therefore must stand out and be emphasised in some way. Bold lettering, careful use of rules or decoration and contrasting colours are effective devices for catching the eye, but in doing so they must not make the message of the piece illegible.

The position of the heading is important. In order to make a visual impact on the reader, the words need to be placed slightly apart from the main body of the text, although they need not stand in total isolation.

The first considerations are the size, weight, style and colour of the letters. Although a heading often appears at the top of the page, this is certainly not the only place, nor necessarily the best place visually for it *(see ideas on pages 114–115)*.

The information given by the title is important and must be seen to relate to the whole design. Study early and modern examples of calligraphy, observing a variety of solutions and do lots of roughs as options. Mark in the body of the text with lines, to indicate the area it will occupy so you can get a better feel for the balance of space.

Give careful thought to the wording if a title has not been supplied. The heading should be thought of as a descriptive statement of the contents of the text, expressed both precisely and succinctly.

If the name of the author, a date or a reference relating to the text is to be included, consider this at the same time as the heading. Often it is this important data that can create a balanced feel to the work, so be careful not to neglect it.

The Jolly Miller

There was a jolly miller once,
Lived on the river Dee;
He worked and sang
from morn till night,
No lark more blithe
than he.
And this the burden
of his song
Forever used to be,
I care for nobody, no!
not I,
If nobody cares for me.

Left: A simple layout incorporating a well-executed heading. When combined with the image, it creates a strong focal point for the piece.

Can you give me some ideas for positioning headings?

The examples on these pages show several creative ideas for using headings and text blocks in unusual ways. In the ones shown below, a line of letters represents a 'real' heading. Headings serve many purposes and their design and placement deserve careful consideration, so spend some time experimenting with different arrangements to find the most suitable and aesthetically pleasing solution.

It may be useful to use a grid system to assist in working out the layout of

EXAMPLES OF HEADING POSITIONS

1 A heading could straddle three columns and be enclosed with a dot or a mark on either side.

2 If the text is composed of individual verses or independent pieces of information, the heading could be located in the middle of the page and centred.

3 When a single word (or very few words) stand alone on a page, a flourish helps make the design interesting.

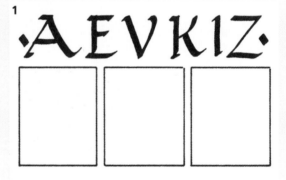

4 A single-word title could be given impact if it ran vertically down one side of the page.

5 A creative alternative to traditional column treatment is shown here, with the title or heading in the centre of the page.

6 Three variable elements – lettering size, positioning, and justification all work together in this layout. A grid system would be very helpful here.

the page. Most printed matter is designed using a grid, enabling the designer to align the work in a clean, legible manner, both horizontally and vertically. It is a good idea to look at some examples of printed work to see how the text and images are laid out on the page, often in columns of a specific width. You will find that rough pen sketches are often sufficient for working out exactly where you want to position your heading.

Can I experiment with different layouts?

Yes, in fact it's a very helpful part of the process. In these examples, a calligrapher has tried out a number of design solutions for a birthday party invitation. Included in these permutations are portrait and landscape layouts that both work well with the wording and style of lettering. Which layout do you like best?

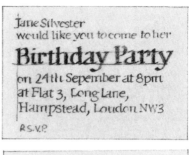

How can I show more detail in my thumbnail sketches?

Look at these images *(below)* for ideas on adding detail to thumbnails. The sequence of thumbnails shows the thinking process as the calligrapher tries out alternative approaches. First, the quotation mentions 'leaping' which suggests a vertical design (**1**). However, trout leap in an irregular fashion, so an asymmetrical design is tried (**2**).

Then the calligrapher finds that a combined vertical and horizontal layout for the river works better (**3**). Finally, the design is refined and the colour of the background is developed (**4**). The finished piece of work combines the splash of the leaping trout with the peaceful colours of woodland and water (**5**).

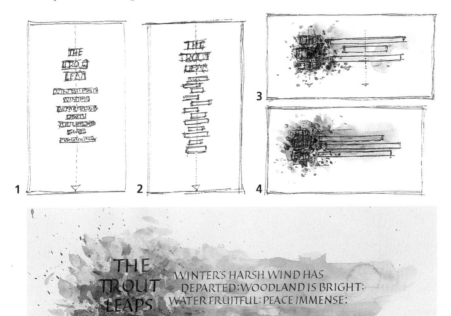

How do I know how much room to leave as a margin?

When you use your writing for a finished piece of work, the margins you choose make an important contribution to the overall effect. To show your writing to best advantage, you need to balance the text against the space around and within it. The amount of space between the lines, between areas of text and between heading and text, helps determine the proportions of the outer margins. Too much space weakens a design; insufficient space makes it look cramped. Generous margins are generally preferable to narrow ones, because surrounding space gives the text unity *(see pages 111 and 117)*.

Many designs use the traditionally proportioned margins found in printing and picture framing and these are easy to calculate. Other designs may flout convention to achieve a particular effect.

CALCULATING MARGINS: Vertical layout (portrait)

For a vertical panel of text, the top margin is gauged by eye and doubled for the bottom margin. A measurement between these two is used for the sides. In the example *(left)* the top might be 5cm (2in), the bottom 10cm (4in), and the sides 7.5cm (3in). An equal measurement for top and sides with a deeper bottom margin is sometimes appropriate *(above and on page 78)*.

You will find that your ability to assess margins will gradually become intuitive.

Side margins should be equal, but the bottom margin should be larger than the top, so that the work does not appear to be slipping off the page. If a title or author's name is used, this should be considered as part of the text area when you are measuring margins.

As well as the more traditional margin proportions shown here, there are many other possibilities where less conventional margins would be appropriate to the mood and layout of the text. These include placing the text high or low on the page with exaggerated space above or below, or placing it to one side of the page *(see page 217, top photograph).* Such margins are more intuitively assessed than 'traditional' margins.

CALCULATING MARGINS:
Horizontal layout (landscape)

For a horizontal panel of text, the widest space needs to be at the sides. In the example above the measurements are 5cm (2in) at the top, 10cm (4in) for the sides and 7.5 cm (3in) for the bottom margin. An alternative formula is shown *(left)*. Side margins should be equal.

What is a focal point?

A focal point is the area of an image to which the eye is first drawn. In the example shown *(below left)* the focal point is the colourful area in the centre of the work. The reader is pulled into the piece by this section as it demands attention and beckons the reader to continue reading. The focal point is not always in the centre of the artwork, as in the example

(below right). In this more abstract rough design, the calligrapher has balanced the left-of-centre text placement with the extension of the wash to the right of the piece. This ensures that the focal point in the darkest wash area is maintained. Always ensure that the words and the image work well together to reinforce the focal point.

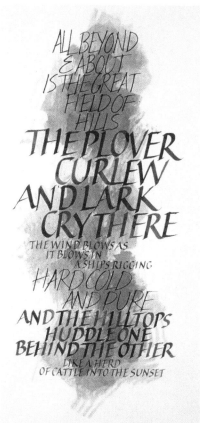

Is a focal point important in a piece that combines calligraphy and illustration?

Yes, a focal point is particularly important in a piece that combines calligraphy and illustration or any other element. When more than one element is used in a single artwork, the elements must all work together to create a singular image. If not carefully executed, the design can appear to be two or three separate pieces 'stuck' together on a single page. Take a look at the sample *(below)*. In this piece of illustrated calligraphy, the composition

was carefully planned around the focal point formed by the flock of birds. The furrows of the ploughed field draw the eye across the text in the foreground to this point. The diagonal movement also provides the link across the horizontal divisions of the sky and landscape. The use of colour enhances the unity of the composition, with the purple-brown of the text echoing both the browns of the fields and the indigo of the sky.

Focal point links foreground, middle ground, and sky.

Passive middle ground balances relative activity of foreground and sky.

THERE'S A WHISPER DOWN THE FIELD, WHERE THE YEAR HAS SHOT HER YIELD,
AND THE RICKS STAND GREY TO THE SUN, SINGING, 'OVER THEN, COME OVER,
FOR THE BEE HAS QUIT THE CLOVER, YOUR ENGLISH SUMMER'S DONE.'

Placement of text helps to emphasise foreground detail.

Diagonal sweep of furrows draws eye towards focal point.

Can I use words as images?

Yes, you can. Calligraphy – with its ability to enhance words by using different styles, forms and colours – is a perfect vehicle for exploring vocabulary in a visual way.

Each style of writing has its historical connotations and its personal interpretive qualities. By understanding the shapes of letterforms and by the actual process of writing, calligraphers gradually evolve their own interpretations and invent new ones.

A couple of examples of interpretation can be seen here *(right)*. The word 'water', written in a flowing Italic hand, is more evocative than 'water' written in stiff upright capitals. The three versions of the word each evoke a different response in the viewer. If it was written in blue – the symbolic colour of water – the calligrapher could go even further to create a mental picture of the word.

The second example, 'dazzle' shows the experiments a calligrapher can make to try to capture the essence of the word.

EXPERT TIP

Creating an image around one letter can add weight and meaning to a word. Here, for example, the calligrapher has added strokes to make rays emanate from the letter 'I'.

How do I judge what a finished piece will look like once it is framed?

Cardboard strips can be used as a framing device to help you determine the most suitable margins for your work. Make a collection of strips in varying sizes from 5–10cm (2–4in) wide. You will need four of each width at different lengths (two long and two short). L-shaped pieces of cardboard or mounting board can also be used. You may be able to obtain scraps from a picture framer, or you could use old mats cut into L-shapes that will together form an adjustable rectangle.

ASSESSING MARGINS USING CARDBOARD STRIPS

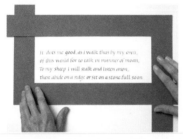

1 Place the strips, or L-shaped mats, like a frame around your work so that you can look at different margin options.

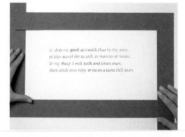

2 Here the text is 'lost' within overly wide margins. Experiment by moving the strips toward and away from the edges of the text.

3 Take care not to cramp the text between narrow side margins, as demonstrated here.

4 When the balance between text and white space looks right, mark the chosen margins with a light pencil point in each corner of the work.

Using Colour

Can I mix my own colours?

Yes, that's the beauty of using paints rather than prepared inks. To understand more about colour, start by familiarising yourself with the colour wheel *(below)*.

The colour wheel is made up of red, blue and yellow – the three basic or primary colours, so called because they cannot be made by mixing other colours. When they are mixed together in equal amounts, they produce three secondary colours. Red and blue create violet, blue and yellow produce green and yellow and red make orange.

Then by mixing a primary colour with a secondary, a tertiary colour is produced. Try it yourself; you should now have twelve different colours.

If you mix the colours directly next to each other on the wheel, you will produce the purest orange, violet and green. Therefore by mixing alizarin red and ultramarine, for example, the best violet

COMPLEMENTARY COLOURS

These colours are directly opposite each other on the colour wheel. The complementary colour of blue is orange. Another way to remember is to say that the complementary colour of blue is the mixture of the two other primary colours – that is, red and yellow = orange.

ANALOGOUS COLOURS

Analogous colours are next to each other on the colour wheel. For example: blue, blue-violet, and violet. When these colours are used together, they create a harmonious effect and mood.

or purple will be produced. Try mixing cadmium red and cerulean blue and you will discover that red and blue do not make purple. This mix produces a warm grey or brown, depending on the amount of each colour you use. Try different mixes and then make notes about the colours that you used – and what was produced – and use them as a reference. For example, complementary colours create visual vibration. Green letters on

red are difficult to read because they neutralize each other when used in equal amounts. However, they can appear to advantage used in small amounts, as they add vibrancy to the page.

The range of colour and media in an art supply store can be overwhelming. Manufacturers create most of their different ranges to match, although confusingly they are not always called by the same names.

UNDERSTANDING MIXTURES

When colours are placed next to one another you can see the colour bias clearly, as the artwork *(right)* demonstrates. The swatches *(below)* show how the choice of primary colour affects the mixture. Those closest together on the wheel create intense secondaries, while those furthest apart create neutrals.

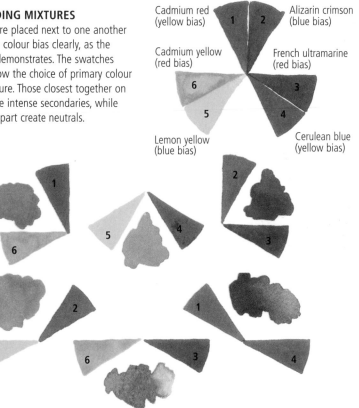

Cadmium red (yellow bias) 1 2 Alizarin crimson (blue bias)

Cadmium yellow (red bias) French ultramarine (red bias)

6 3

5 4

Lemon yellow (blue bias) Cerulean blue (yellow bias)

How do I use gouache in calligraphy?

Gouache is an opaque water-colour that is frequently used in calligraphy. It is opaque because it has a white pigment, or filler, added that creates a dense, flat colour when used. It is often used by graphic designers and is ideal for using in pens and for bright illustrations. However, it tends to streak when it is being used with a brush to create thin washes. Writing with gouache – because of its opacity – is very reminiscent of the writing in medieval and Renaissance manuscripts. Its appearance in a finished piece closely resembles the results when using pigment and egg tempera, which are commonly used in those manuscripts.

How do I use watercolours in calligraphy?

Watercolours are most often used for background washes (see page 133) or separate illustrations alongside calligraphy, rather than for the actual calligraphic lettering. Standard watercolour is not opaque. When mixed with enough water to allow it to flow through a pen, the resulting colour is too watery and allows colour 'pooling' or puddling at the bottom of the letters. Generally, this is not considered to be a satisfactory result, except in those instances where an unusual effect is desired. When using watercolour and gouache in the same piece, there is a danger of a feeling of imbalance, as watercolour is delicate and translucent and gouache is strong and solid.

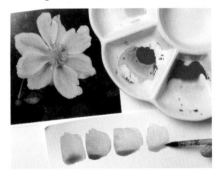

Left: *When you are using watercolour paints, test them on the paper you are going to be using before starting the final artwork.*

How should I fill my pen with colour?

If you fill your pen by dipping it directly into the ink or paint, it is difficult to control the amount of liquid in the reservoir, and you may get drips on your paper. It is therefore advisable to use a brush to feed ink or paint directly into the reservoir. Always make sure there is no ink or paint on the upper surface of the nib.

FILLING WITH INK

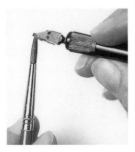

Fill a medium-size paint-brush with ink. With the brush in one hand and the pen in the other, feed the ink in from one side between the nib and the reservoir. A dropper may be used instead of a brush to load ink into the reservoir.

Alternatively, after dipping your pen in the ink, touch it briefly on a piece of absorbent fabric and make a sample stroke or two on scrap paper. These actions will make sure the ink is flowing smoothly and will eliminate the ink blob that sometimes collects when dipping the nib.

FILLING WITH PAINT

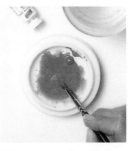

1 Squeeze out about 6mm (¼in) of paint or gouache. Add water and blend well with a soft paintbrush until the mixture becomes the consistency of ink.

3 Test the paint flow on a piece of scrap paper. If the paint is too thin, the colour will not be strong enough. If the paint is too thick, it will clog the pen.

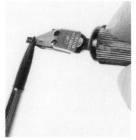

2 Load the pen using a brush, either from the side or through the reservoir. Here, the pen has been turned upside down so the reservoir faces up for easy loading with colour or ink.

4 Make sure you mix enough paint to complete the job. A change to a new batch of colour halfway through is likely to show.

How do I letter in colour – and in more than one colour?

There are several ways to render calligraphy in colour. The basic technique is shown below – as well as how to add a second colour *(Steps 3 to 7)*. Most calligraphers prefer to mix their colours from gouache, rather than using ink, because it gives more solid coverage and allows a vast array of colour possibilities.

YOU WILL NEED

Pans or tubes of colour
Water
Paintbrush
Dip pen with
 detachable nib

Palette
Paper

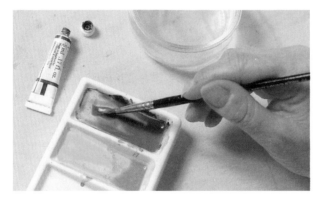

1 Mix the colour to the consistency of single cream, which will be thicker than ink. Be sure to mix enough to do all the writing. When two colours are mixed together, it is always difficult to mix more of the same blend because colour varies from wet to dry.

2 Add the colour with a brush from the side or from underneath *(far left)*. Adding colour to the top of the nib (unless it has the reservoir on top – a Brause nib) will cause the paint to blob.

3 When the paint just begins to thin, replenish it by adding more paint to the nib with the brush. Two or more colours can be used to create very interesting effects *(left)*.

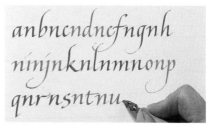

4 Try adding a second colour when you refill your pen *(above)*. The original colour and the new colour will blend as you write, making a gradual change, which is generally better than an instant change, although in some cases you may want a sharp division. Other colours can be added in the same way to create soft colour blends.

5 Try using analogous colours that sit together on the colour wheel, such as orange-yellow and cadmium red *(above)*.

6 By employing the technique described in Step 4 and using white as the second colour, you can achieve a very interesting gradation effect. Start with the dark colour – in this case, dark blue *(right)*, and gradually add white so that the colour you are writing with subtly changes to light blue. Then start adding the dark blue back to your pen again to bring your colour back to the shade you started with.

7 Use two complementary colours, such as blue and orange, red and green, or yellow and purple. These combinations will cause a vibrant effect *(left)*.

How do you stretch paper?

Background washes use a great deal of water which will wrinkle the paper unless it is a heavyweight one – that is, 356gsm (260lb) – or more. Lightweight paper therefore needs stretching before using, as shown *(below)*.

YOU WILL NEED

Paper	Sink or bowl
A board (particle/	A sponge
medium-density fibre-	Brown gummed
board, or plywood)	paper and tape

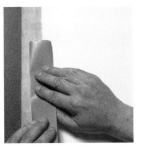

1 Make sure the board is slightly bigger than the paper to allow for the tape.

2 Carefully place paper in cold or tepid water, keeping it flat. Leave it for a few minutes to ensure it is thoroughly wet.

3 Holding two corners, lift the paper from the water and let the excess water drain. Place carefully on the board, lowering gently to exclude the air.

4 Use a sponge to blot the surface with great care. On a large sheet of paper, always work away from the centre. Do not apply any pressure; this will damage the surface.

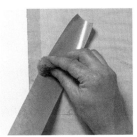

5 Cut four strips of gummed paper tape to place along the four sides of the paper. Wet each piece of tape with a fairly damp sponge.

6 Tape one side, then the opposite side and then the other two sides. Allow an overlap of tape on the paper of about 12.5mm (½in) and press each down firmly. Lay the board flat and let it dry away from direct heat.

What is the best way to create a background wash on paper?

Here's an easy technique for creating a background wash. Although this example *(below)* uses a bristle brush, sponge brushes are also effective. By using a background wash it is literally possible to create a background of any colour on the colour wheel *(see page 126).*

YOU WILL NEED

Stretched paper *(see page 132)*	A deep palette or mixing bowls
Large, soft brushes	Clean water for rinsing brushes
Watercolour paints	
Lots of water	

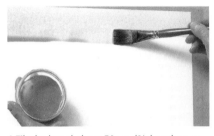

1 Tilt the board about 50mm (2in) at the top end. Leave the stretched paper on the board. Mix the paint in a bowl with plenty of water. Load a large, soft brush with paint and draw it horizontally across the top of the paper. Do not stop until you have reached the other side.

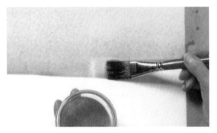

2 Load the brush again. Now make a second stroke in the same way, slightly overlapping the first stroke. Continue working in this way toward the bottom of the sheet.

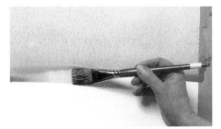

3 Do not patch any missed areas. To prevent streaking, there should be enough liquid in each line to create a long puddle at the bottom of each stroke. Overlapping this line fractionally will allow each stroke to blend together.

4 When you reach the bottom, rinse the brush, dab off the excess water, and run it along the bottom puddle to pick up the excess paint. Lay the board flat and dry it as before. If the colour needs to be darker, repeat the process.

How do I make a background colour lighter?

Making your background colour lighter is simply a matter of adding more water. The more water that is added to the watercolour, the more translucent it becomes. Depending on the colour of your background wash, you may choose to vary the intensity of it, allowing your calligraphy to stand out. This technique is called a graded wash and can be done by following these directions.

MAKING A GRADED WASH

1 Tilt the board. Mix the paint in a small jar. Load a large brush and draw it horizontally across the paper, continuing directly to the far side. After one or two strokes, add more water to the paint mix.

2 Continue down the paper, adding water to the paint after each stroke. The colour should gradually get lighter as you add water, as shown *(left)*. Finish the wash by soaking up the watery paint with your damp brush and letting the paper dry, as described on page 133.

Can I use two different colours in a background wash?

Yes, incorporating two or more colours into a background wash can be done with great success. Some caution must be exercised as colours can become muddy when they are mixed. A little experimentation on scrap papers should help eliminate this problem. The description that follows takes you through the process of allowing two background colours to mix together.

1 Mix the two colours required in two separate suitable containers. Tilt the board at the top and lay a wash to the centre.

2 Turn the board around and, using the second colour, work again to the centre, overlapping the two colours slightly.

3 Allow the colours to bleed into one another.

4 The more watery the colour, the more 'run' you will get. Bear this in mind when you are mixing your colours. After satisfactory blending has been achieved, lay flat to dry.

What is a variegated wash?

A variegated wash is similar to a two-colour wash, but there is a slight variation in the technique. The mixture of the colours is more random and the paper may not be completely covered with colour. This treatment can tend to be a little more dramatic than the previously described background washes. Here is how it is done.

1 Use a wet-into-wet technique. Wet the paper and allow a few minutes for the water to soak in (until the paper looks matt rather than shiny). Meanwhile, mix three or four colours. Load a large brush (No. 8–10) with the first colour and paint some areas of paper, leaving the other areas white.

2 Rinse the brush and load it with the second colour *(circled)*. Dab it into the white spaces. Watch what happens as it blends and moves on the damp paper.

3 More colour can be applied to desired areas. Brighter colour can be added by using thicker paint. If it appears too bright, tone the colour down by adding more water. This way you can control the amount and depth of colour in the background. Certain colours mixed together cause granulation to occur; try using alizarin red and ultramarine blue.

EXPERT TIPS

- *This technique is great for creating subliminal imagery such as swirling greens and blues to create an 'earth-like' image, or various shades of blue to conjure thoughts of the ocean.*

- *A few precautions should be taken to avoid colour mixing in unwanted places. For example, a layer of sandarac between the background wash and your calligraphy will help keep the calligraphy colours separate from the background colours.*

- *If some areas of the paper remain unwashed, your pen will feel and behave differently on those spots than on the washed areas.*

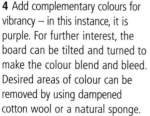

4 Add complementary colours for vibrancy – in this instance, it is purple. For further interest, the board can be tilted and turned to make the colour blend and bleed. Desired areas of colour can be removed by using dampened cotton wool or a natural sponge.

5 Now that the desired effect has been achieved, lay the board flat to dry. If the results appear disappointing before the paper dries, wet it (preferably under running water – a shower head is ideal) and carefully sponge the paint away. Dab off excess water. Leave it to dry and begin again.

Can I use a stencil to create designs that go with calligraphy?

Yes, stencils can make decorating a letter pretty simple and they are fun to make. The example shown here uses pastels with a stencil and creates a soft and attractive effect. Stencils can be cut from cardboard or acetate – the latter works well with calligraphy as it helps you to place the design accurately *(see Step 4)*.

YOU WILL NEED

Paper	Acetate
Pencil	Craft knife
Tape	Pastels
Cutting mat	

EXPERT TIPS

- *Stencils need a fairly large, open area to be effective, so keeping the design simple is important.*

- *This example uses pastel with a stencil but lots of other possibilities exist. Try experimenting with a second colour of paint (rather than pastel), or a 'spray' of paint using the spatter technique that is shown on page 140.*

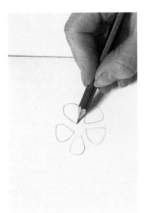

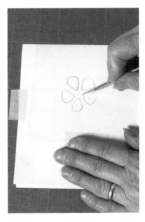

1 Draw a simple design on paper. Here a simple flower shape is being used. If you find drawing difficult, trace an idea from another source, keeping only an outline and keeping the shapes as simple as possible.

2 Tape your finished design on to a cutting mat or a piece of thick cardboard, so that it does not move and to protect the table that you are working on. Place a piece of acetate over the top and tape it securely.

3 Using a craft knife, carefully cut out the design. The areas that are cut away will be the design made by the pastel.

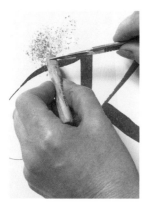

4 The design can be used to decorate one letter or whole pieces of writing. Using acetate instead of cardboard or a conventional stencil means that you can see where to put each single design. Place the acetate in the chosen position and tape securely. Scrape pastel on the design.

5 Carefully rub the pastel through the stencil – lightly first, then quite firmly.

6 Scrape a second colour on to the design.

7 Lift the acetate to see the result. Choose another area for the design and repeat. Continue until you have created the effect that you want. Any number of different colours can be added. Remember to use a piece of clean and absorbent cotton wool for each colour so that you can keep the cotton wool fresh.

What is the spatter technique?

Spattering paint or ink over a surface is the low-tech version of airbrushing! Very attractive effects can be achieved with an old paintbrush loaded with colour and flicked with your thumbnail or a ruler to spatter the paint.

YOU WILL NEED

Paper	Leaves or cut-out design
Ink or paint	Apron and old
Toothbrush or	newspapers for
paintbrush	protection

SPATTERING PAINT OR INK

1 Paper cut-outs or leaves laid on the paper will produce patterns and silhouettes when they are removed. The reverse effect would be to spatter paint through a stencil. Make sure to shield yourself and the work surface.

2 When you have completed spattering, lift the leaves off carefully, taking care not to smudge the paint; consider developing several layers of spatter, having moved the leaves or images with each layer.

3 When you have perfected the method, consider how you could use such a decorative element with some text; in this example, a poem about falling leaves would fit well.

What is the masking-fluid resist technique?

This technique involves applying masking fluid before you apply paint. This is done because paint will not 'take' to the paper when masking fluid is applied to it, enabling you to create an interesting resist effect in your work.

YOU WILL NEED

Paper
Masking fluid
Paint

Old brush, cardboard
or cotton bud

1 Using an old brush, a piece of cardboard or cotton bud, write patterns and/or letters using masking fluid. Metal pens work well and will not be damaged, but need frequent wiping to prevent clogging.

2 When the masking fluid is dry it appears matt. Next, apply the paint; lay colour washes on the paper, loading the brush well.

3 At this stage, while it is still wet, you could add other colours. They will run into each other, so choose colours that blend well. When you are satisfied with the result, leave it to dry completely.

4 Rub away the masking fluid with your finger, using a gentle circular motion; it should come away in rubbery strings. Take care not to damage the paper surface by rubbing too hard, especially if you plan to use this method to develop a background technique.

How is an eraser stamp design made?

Eraser stamp designs are a good way of adding a simple embellishment to a piece of writing. They are made by first cutting an eraser with a craft knife or linoleum cutting tool. Then the eraser design is pressed on to a purchased or home-made stamp soaked with paint or ink and then pressed on to the paper to repeat the pattern. Any clearly defined design motif can be used. Remember the design will be reversed when it is printed. The area that is cut out and discarded will remain white. The relief or raised area will be the part that prints.

YOU WILL NEED

Soft pencil

Paper

Eraser

Craft knife

Stamp pad

Fibre-tipped pens

EXPERT TIPS

- *This fun technique has lots of possibilities – the images carved into the eraser are only limited by your imagination. The stamps can be mixed and matched to create even more design possibilities.*

- *Large designs can be created using large erasers. Any size eraser can be cut to fit the approximate size of your design.*

1 Draw or trace a pattern on a piece of paper, using a soft pencil. Keep the design simple so that you can cut the shapes easily.

2 The design can be drawn straight on to the eraser. Alternatively, the paper can be placed pencil-side down on the eraser and drawn again. This will cause the graphite design to be deposited on to the eraser.

3 Remember that the printed design will be reversed. The areas that are cut away will remain white; the raised areas will be coloured. Carefully cut the design with a craft knife – cutting away from your fingers.

4 Press the eraser into a stamp pad soaked with ink, then press it on to the paper. Alternatively, coloured fibre-tipped pens can be used to paint the eraser first, which can then be stamped on to the paper.

5 Continuous border patterns can be created easily. Changes of colour make it more interesting *(above)*.

6 Delicate leaf patterns and flowers can be created as motifs for letter headings and cards *(below)*. Stamps made this way can be used over and over again and in different combinations.

Can I etch my letters in paint?

Yes, there are several techniques for creating 'relief' in your work. Here is one interesting technique *(below)* that involves adding paste to paint, so that the paint becomes thick enough for you to 'etch' or 'carve' your letters in the colour.

It opens up many possibilities for using creative utensils as 'pens'. For example, your letters could be 'striped' if you use a wide-toothed comb as your pen nib. Also, by using coloured paper, you can add more colour to your design.

ETCHING LETTERS IN GOUACHE

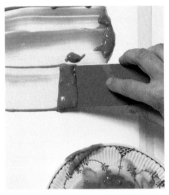 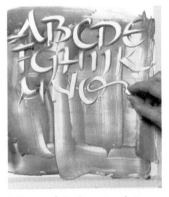

1 Mix a small amount of wallpaper paste and add some paint – gouache was used here straight from the tube – then spread it freely over the paper with a piece of cardboard, moving in at least two directions to achieve good coverage. Experiment with how thickly it can be laid.

2 Use a soft implement such as a piece of eraser and scrape marks or letters into the surface. One colour has been used here and the scraping reveals the white underneath. The slippery surface gives uninhibited free movement. If it goes wrong, re-spread the paste and try again on top of the fresh surface. It will dry fairly flat but it will give a 3-D shadow effect along the edges of the letters or marks.

Can you use pastels for colouring a background?

Yes, dry pastels can be used to colour a background. Follow the instructions *(below)* to try this technique. It is important to ensure that the background you create provides contrast with your lettering.

YOU WILL NEED

Paper
Pastels
Craft knife
Cotton wool
Fixative (optional)
Eraser

1 Soft pastels are used to create soft backgrounds without paint. If you use pastel directly on the paper, lines and streaks will appear. For a soft blending of colour, scrape a small amount of pastel on to the paper with a craft knife. Alternatively, rub a piece of cotton wool on the pastel, picking up the colour required.

2 Gently rub the pastel into the surface with a piece of cotton wool. Using a circular movement prevents any unwanted lines from appearing and gives you more control over the media. More pressure can be added to blend the colour into the paper.

3 Continue moving in circles when adding more colour, as blending will be easier and smoother. Remove unwanted colour with an eraser. Pencil lines removed after writing leave white marks. Touch in with coloured cotton buds.

4 Subtle blends of colour can be created very expertly with this method of colouring paper. When the pastel is rubbed in firmly there should be little need to use a fixative. Writing with a pen on top is pleasurable as no bleeding or changes of colour occur.

Free-form Lettering

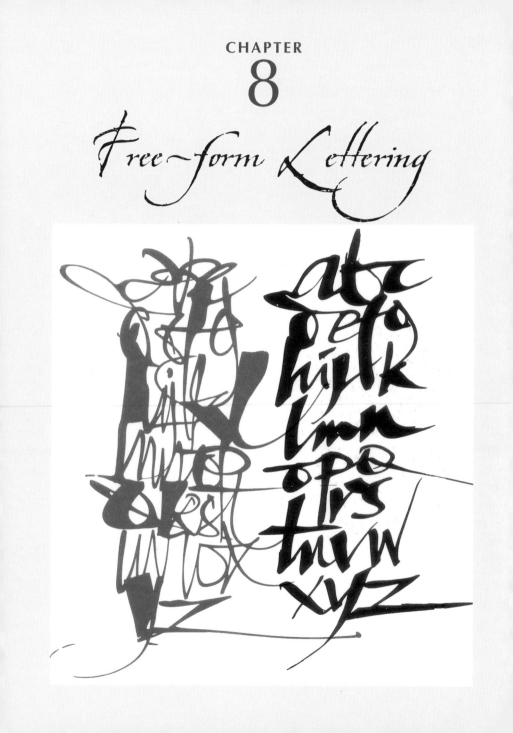

How can I create letters that are a little more abstract in form?

Once a solid understanding of letter proportion is accomplished, try leaving some of the rules behind. For example, don't use pencil guidelines, just write very freely and see what happens. Try different kinds of pens and brushes to see what effects they create. Keep in mind, though, that often the lettering that looks the most spontaneous is actually the most carefully planned out.

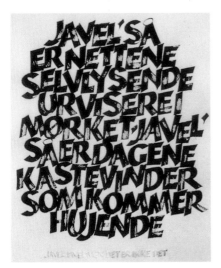

Above: *The use of heavyweight capitals with close interlinear spacing creates a very lively graphic effect. The small gilded capitals provide a bright and unusual contrast.*

Right: *This is a fine example of successful abstract lettering. The tall, compressed slanting letters give a strong diagonal emphasis to the overall design.*

Can other tools and instruments be used for making free-form letters?

Yes, use your imagination and try something new! The sample alphabet shown here *(right)* was made with a lolly-pop stick or similarly shaped flat, wooden stick. Some very interesting results can be produced because the tool 'rides' along the paper surface differently than a pen, and the ink flows differently from it. There is inconsistency in stroke thickness, but in the hands of a capable calligrapher, balance and beauty can still be achieved.

Can other art forms and mediums provide inspiration for calligraphy?

Inspiration can be found just about everywhere – in nature, in museums, in libraries, around your home and so on. In the sample shown here *(left)*, the artist was inspired by the design of Russian icons, which incorporate gold leaf, frame-like borders and Cyrillic calligraphic messages. Usually the image of Christ or other holy figures are featured in the icons, but in this case the calligrapher has chosen to let the written message be the focal point. In the style of lettering chosen, the calligrapher echoes the Cyrillic style of a Russian icon.

Can free-form lettering be done with a ruling pen?

I take the word and go over it
as though it were nothing more than human shape
its arrangements awe me and I find my way
through each variation in the spoken word –
I utter and I am and without speaking I approach
the limit of words and the silence.

I drink to the word, raising
a word or a shining cup,
in it I drink
the pure wine of language
or inexhaustable water,
maternal source of words,
and cup and water and wine
give rise to my song.

This can be done very effectively. Lettering created with a ruling pen *(see page 19)* can have a very free, spontaneous appearance, as shown in the above example of a landscape book layout.

Above: *In this book, the freely written Italic-based script – lettered in red gouache with a ruling pen – contrasts strikingly with the black, broad-edged pen Italic.*

Can I combine free-form lettering with more traditional lettering?

MONTAGNA ACQUA

Yes, you can. The piece shown *(left)* is a very good example of freeform lettering combined with traditional calligraphy. Remember, though, that the overall design should be balanced. This does not necessarily mean symmetrical, but a visual balance of the piece is desirable.

Left: *This title page shows a design created by contrasting formal Italic broad-pen capitals with a lively Italic. Both ink and gouache have been used.*

Can the insides of letters be filled in to add colour?

Yes, the insides of the letterforms – also called the counters – can be very effectively coloured in with miniature illustrations or a variety of colours. Look at this example of the alphabet *(below)* that has been treated in that way.

Above: *A small delicate panel of freely written Italic in indigo gouache and black ink. The subtle coloured shapes in and around the letters are painted in watercolour. Note how the letterforms progressively increase in size and freedom.*

What techniques can I use to add texture to my lettering?

Texture can be achieved in many ways, including a dry-brush technique such as the one used in this alphabet *(below)*. 'Dry brush' refers to a technique whereby the brush is lightly filled with ink or colour. When a stroke is made, the coverage on the paper isn't solid, allowing the texture of the paper to be seen through the stroke.

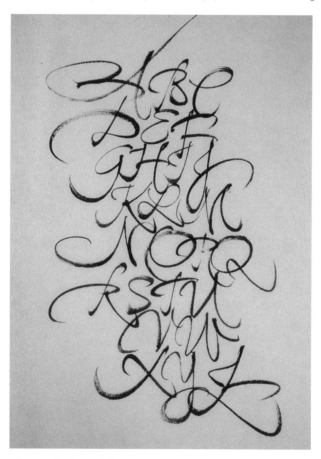

Above: *This beautifully designed and executed alphabet of capitals shows an individual, lively and flowing Italic letterform.*

Is it feasible to use multiple lettering styles in one piece?

Yes, you can use multiple lettering styles in a single piece – as the successful example *(below)* shows. This sometimes means breaking design rules. Rule breaking here has worked because the different sizes of letterforms are carefully balanced. The mixture of lettering styles, colours and direction of text produces real movement on the paper and the text seems to 'dance' across the page.

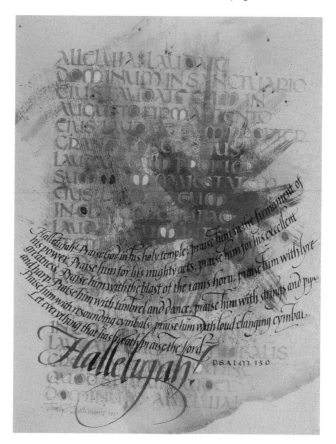

Above: *Several different lettering styles are used very effectively here, with the largest word forming an unusual focal point.*

Can I use a brush for calligraphy?

Yes, brush lettering is a beautiful way to render calligraphy. There are several different types of brushes that can be used and they are excellent tools for practise and experimentation. The ability to use different brushes and a variety of inks and paints is a great asset, providing a range of instant visualizations.

When working with brushes, you will soon realize that, having found a successful solution in rough form, recreating the exact same image in the finished work is not easy. Because of the free movement of the brush, a good understanding of letter shapes is essential to achieve convincing lettering.

Brush lettering can be incorporated in a wide range of designs, creating strong visual effects with an enticing air of informality. For example, a brush-lettered headline – either standing alone *(opposite)* or next to more formal typography – is very effective, as examples from 1930s and 1940s advertising show.

The best way to learn the possibilities of brush lettering is to work on quite a large scale and freely in an informal style. A 'hidden agenda' exists when working with brushes; particularly when the ink or paint on the brush diminishes, resulting in interesting textural contrasts. For example, if the ink runs dry in mid-

1 Working with a large square-cut brush permits the calligrapher much freedom of individual expression. The first letter provides an anchor from which the remaining letters can hang or around which they can be grouped.

2 The letters are constructed in the traditional manner of following a stroke sequence. The brush is held at an angle either suitable to the chosen style of lettering or to produce the intended weight of stroke for a particular piece.

3 Pleasing arrangements can be arrived at, sometimes unintentionally, when you are practising free-form lettering with a brush. An extended stroke to create a swashed letter is easily accomplished with a brush.

letter, you can make a positive feature of the change of emphasis, rather than dispensing with the work.

Experiment by placing wet, different colours side by side and letting them merge. Planning the colour selection can produce exciting and interesting results.

Discovering which brush to use is a matter of trial and error, so get to know the marks of as many brushes as possible. Broad, flat, or square-cut brushes produce bold lettering *(below, left)*. Manipulation of the brush angle, especially when making a horizontal stroke, creates further interest.

Above: *Brush lettering was a popular technique for 1930s and 1940s advertisements. It provided a powerful visual effect and at the same time created an informal atmosphere.*

What other kinds of brushes can be used for calligraphy?

Pointed brushes produce beautiful letters and are excellent tools to help you in developing a rhythmic and fluid style to your free-form lettering. Chinese pointed brushes are ideal too and are designed to hold much more paint or ink than a traditional Western watercolour brush.

USING A CHINESE POINTED BRUSH

1 A pointed brush, of the kind used for Chinese calligraphy, is excellent for practising freely constructed letters.

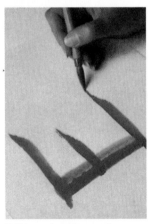

2 Chinese brushes are also versatile: fine strokes can be produced with the tip, and broad strokes with the body.

Above: *A Chinese motif designed for a greetings card. The modern-style characters were written with a pointed brush.*

USING A POINTED BRUSH

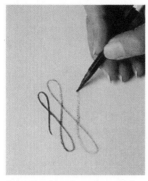

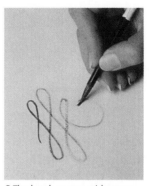

1 A pointed brush can be used for lettering and for creating fluid flourishes. Successful flourishing requires practice so that the strokes can be accomplished in a relaxed manner and flow naturally.

2 The brush moves with great agility to create expressive arcs and lines. Varying the pressure on the brush produces lines that vary from thick to thin in one continuous stroke.

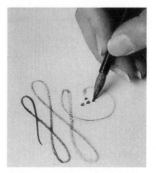

3 Flourishing exercises can be interesting pieces in their own right. Here the addition of red dots, made with the tip of the brush, provide a finishing touch.

4 Practise making traditional flourishing shapes and simple marks before attempting to apply the lines as letter extensions.

Embellishments and Borders

What sort of ornamentation is appropriate for calligraphy?

In calligraphy, ornament may fill an entire margin, create a border for the text or a background for a capital letter. Delicate patterns and repeated symbols can complete a line where the text falls short and does not align. The intention in using ornament in calligraphic design is to achieve absolute harmony throughout the entire work and it must be planned in from the start, not added as an afterthought.

Special attention needs to be paid to proportion and the symmetry of shapes and colours. Begin by including simple geometric figures – like a square, circle, triangle, oval and lozenge *(see page 161)*. Then introduce a connecting element *(see page 162)*. More ambitious solutions can be attempted by including simple motifs from the natural world. When selecting the 'ingredients', be sure to use a good model.

Above: *A stunning piece of gilded ornamentation that uses geometric shapes effectively. It was originally designed to be used as an end note or finishing piece in a Royal Charter.*

What kinds of patterns should be used in ornamentation?

The best starting point for learning to apply ornament is to study the basic construction methods that are shown below. Simple patterns can be generated on a network of lines crossing each other at different angles. Begin by building patterns along lines placed at right angles to one another and at equal distances (**1**). You will find graph paper useful here. Fill in individual shapes to produce squares

and diamonds and adjacent squares to produce oblongs (**2**). Introducing oblique lines that cut across the squares and oblongs produces triangles (**3**).

To create ornament based on hexagonal shapes, place lines at an angle of 30° and cross with vertical lines (**4**). To create octagonal shapes, place lines at an angle of 45° and cross them with vertical and horizontal lines (**5**).

1 **2** **3**

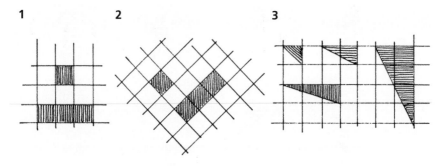

4 **5**

Can curves and geometric shapes be used in ornamentation?

Yes, look at some of the variations of geometric patterns shown below to gather ideas for your ornamentation. The examples *(below)* include working with shapes like diamonds, squares, circles, ellipses, octagons and ovals. When you introduce a connecting element with lines, chains, spiralling cables, zigzags, waves or a running scroll you can see how the possibilities for creative design open up to you. The size of ornament should relate closely to the scale of writing and size of the page. If the ornament is in a manuscript book, the scales should remain consistent throughout the volume.

1 Altering the lines and shapes applied to the basic network of lines begins to extend the language of ornament. Here the horizontal and vertical lines provide the framework of a pattern used extensively in heraldry, known as embattled.

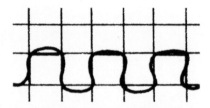

2 Here the lines of the embattled pattern have been curved to create a meander.

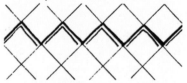

3 A squared grid that is set at 45° to the horizontal, created the diamond – used here as a framework for the chevron zigzag.

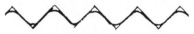

4 Using the same network, but curving the apexes of the zigzag, creates the wave.

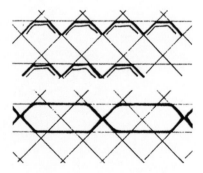

5 The same network, with the addition of horizontal lines, is the basis for the blunted zigzag *(top)* and the interlace patterns *(above)*.

6 The geometric lines of the zigzag are here rounded to produce the scallop. The interlace pattern is adapted to produce the scale pattern.

7 The squared network provides the foundation for construction of the fret. This familiar geometrical figure forms the basis of many fine ornamental borders.

8 The spiral is created by rounding the straight lines and sharp angles of the fret.

9 The wave and the running scroll are adaptations of the spiral.

10 The interlace constructed on the network of crossed diagonal lines can be enlarged to form a double wave or meander.

11 By converting the rectilinear network to one of circles and ellipses, further ornamental elements can be added to your repertoire. These include the chain and cable.

How do I repeat a design to create a pattern?

The diagrams in the previous question illustrate some of the elemental forms and lines found in styles of ornamental art and upon which more elaborate details can be built. The same principle of networks is used here to show different methods of laying out ornament and how you can repeat designs to create a particular pattern.

1 The method shown here involves filling in each square. This is known as diapering.

2 Working on the same squared grid, but omitting alternate squares, this method is known as chequering.

3 Techniques of diapering and chequering can be combined effectively to create solid patterns.

4 This method employs the same principle but allowing larger spaces between the filled-in areas. This is referred to as spotting or powdering.

5 Applying the ornament in rows and leaving some rows void creates striping. Versions of striping constructed in a narrower vein are called banding.

6 A combination of striping and banding produces another layout, called panelling.

Can these repeated ornaments be used in decorated letters?

Yes, here is an example of how to incorporate patterns and ornamentation into decorated letters – this method provides a valuable foundation for illumination and decoration. First, the basic squared grid is drawn (**1**) and the letter is superimposed. It has a network of lines arranged at 30° to the horizontal.

Using this arrangement of lines, ornament is applied to both the letter and the base ground (**2**). The squared grid provides the basis for a repeat pattern. To repeat this particular pattern, the lateral repetition has been achieved by lowering the pattern to fit two sections together.

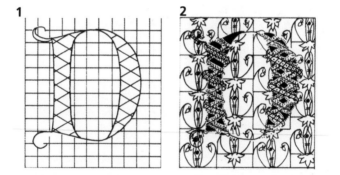

How do I create corners that are in keeping with the border patterns?

It's very important to carefully plan out the corners of your borders so as not to disrupt the border pattern *(see page 213)*. The corner is the best place to start when designing a border to form a full or semi-enclosure. Here are three suggested ways to plan corners, including oblique (**1**), square (**2**), and joggled mitre (**3**).

Can I use fret, key and other traditional geometric patterns in my borders?

Fret patterns can be used as borders on their own, or they can be incorporated with ornament and embrace an enlarged letter. The basic structure of fret patterns can be used as a framework for decoration not composed solely of straight lines.

The simplest forms use lines that are all either vertical or horizontal. The distance between the lines is the same as the width of the lines. As with other basic ornament structures, using graph paper will help you to plan your designs accurately.

1 This geometric border is six widths wide, the top and bottom lines are continuous and the vertical lines are three widths high. Developing this nature of analysis is the best method of understanding how to construct these designs.

2 This pattern is seven widths wide. It is an expanded version of the first example, with the introduction of horizontal lines. In these patterns the 'negative' shapes formed by the ground (here, the white of the paper) are as important as the positive shapes of the marks made.

3 This pattern is known as the key pattern. It shows a balance of black and white (negative and positive); an important feature in fret designs.

4 The introduction of slanting lines to the framework produces a sloping fret. Here the horizontal lines are retained, but the vertical lines are replaced by lines set at an inclined angle.

5 The pattern *(left)* is interlace strap work. Draw vertical and horizontal lines and lines placed at a 45° angle.

Can I use my calligraphy pen to create a border?

Yes, in fact creating strokes for a border with a calligraphy pen is a very good starting point for someone who is new to calligraphy. A broad pen can be used to produce simple and pleasing marks that, either alone or in combination, can be repeated to create a decorative border. Changing the pen angle will increase the variety and interest even within the same border. Study the samples *(right and below)* for ideas.

MAKING A LETTER BORDER

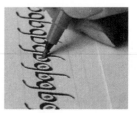

1 Borders constructed from letter shapes can be used successfully, especially if the letters have been chosen to represent or allude to something referred to in the piece they surround. If there are no obvious links, letters that contrast with or balance each other can be selected.

2 Repeating the letters, with their elegant proportions and thick and thin strokes, leads to a perception of an arrangement of shapes rather than actual letters *(above)*.

3 The inclusion of a spot colour, as a simple device, can add a surprise element and further disguise the actual letter shapes.

4 This picture *(left)* perfectly illustrates how the letters have become mere vehicles in the creation of this border. The work has a balance of black and white and reads as a row of shapes and lines, rather than letters.

Can I use colour in my pen for a border?

Yes, you can. Repetitive marks in colour can make very interesting and decorative edge patterns and borders. Inspiration for the shapes can often be derived from the strokes of the letters that you are already using in a piece of work.

YOU WILL NEED

Papers, plain and coloured

Pens

Ink or paint

Glue stick

COLOURED PEN PATTERNS AS BORDERS

1 Experiment with shapes similar to those you have used for letters and see how decorative they can become by making them repeatedly. Try repeating the same design the other way up, by turning the paper around.

2 Turn the page at a right angle and continue the patterns at each corner. If the pattern is very complex, you may find it easier to stop short at each corner and leave a gap to be filled later with a different shape.

3 When decorative elements have been completed – here, squares have been added in the outer semicircles – clean up the corners if necessary by adding another related shape, in this case a circle has been used.

Can I use more than one nib size?

Yes, it makes a nice finishing touch to a calligraphy piece as you can see *(below)*.

Try out this technique – you could also add a second colour to add extra interest.

USING TWO PENS

1 A simple repetitive pen stroke can be elaborated by alternating one stroke of a wide pen with two of a narrow one.

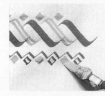

2 You can try out smaller, similar patterns underneath, linking the colours and styles of your calligraphy strokes.

Can I use a brush to make a border design?

Yes, both square-cut and pointed brushes can be used to create attractive border designs *(below and bottom)*.

Experimenting with different tools and media will add variety to your calligraphic repertoire of strokes and marks.

BROAD BRUSH BORDERS

1 A brush with a square-cut end can be used to create a border composed of simple repeated shapes.

2 This example is based on a brick bonding design. The same arrangement can be made using a broad nib.

POINTED BRUSH BORDERS

1 Manipulate a pointed brush with gouache to produce varying weights of mark. Here the calligrapher is using no noticeable pressure to create fine lines.

2 Applying a little pressure and pulling down quickly through the stroke produces a contrasting bold line, as shown here.

3 Delicate dots can be added using the tip of the brush. Control of the dot size is dictated by the pressure placed on the brush as it rests on the paper.

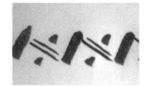

4 The dots in this completed simple border pattern were made by placing the point of the brush on the paper, then pulling it slightly downward as it was lifted off the paper.

How do I design a floral border?

Although good calligraphy should be able to stand alone, there are situations in formal or creative work where decoration can enhance the written text. As with any other form of decoration, the border must be appropriate to the subject and script and form an integral part of the work as a whole.

In the example *(below)*, the text, with its references to nature, seems to suggest a flower border. The border also creates a well-balanced layout with the text.

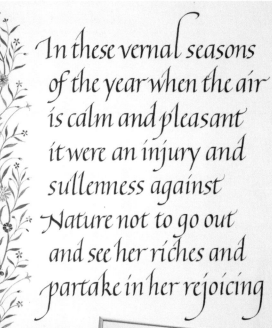

Above and right: *The delicate floral border, together with the elegant italic text, would be overwhelmed by a heavy frame and mount. A fine gold frame discreetly complements both the calligraphy and the decoration.*

Should I use a sketched thumbnail to start?

Yes, a good plan will enhance the final product *(see page 111)*. The first step is to decide on the page format and on the placement of the borders. You can try producing a variety of thumbnail sketches *(below)*. In this example, the final design that is chosen is vertical with a single border along the left margin *(far right)*.

Border at left and below

Border below

Border on all sides

Border at top

Border at left

How do I decide which style of border to use?

It is best to make your decision on the final design by making some trial illustrations. The choice is between designs of varying complexity and whether to include repeating elements.

1 Simple alternating flower and foliage motif with a strong central linear element.

2 Undulating central stem with a non-repeating design.

3 Three-part design of non-repeating complex flower-and-stem pattern.

4 Complex flower and stem pattern with strong central emphasis and repeating colour combinations.

pink

blue

pink

1 2 3 4

How do I put the text and border together to make a harmonious design?

For the final layout, the border design shown in example **4** *(see previous question)* has been selected for development. The decision is made to use Italic for the text with simple flourishes at selected points to break up the outline. The gentle flourishes imitate the flow of the leaves and stem in the border. The colours that have been used are clear and bright, but not so strong as to overwhelm the text.

PASTING UP THE FINAL LAYOUT

1 Write up your text for the final paste-up using a Mitchell No. 3 nib.

2 Paste up the text and cut each line to length only when the line length is established.

3 The finished paste-up of the border design *(right)*.

Border along left margin only

Dense floral design with repeating colour combinations

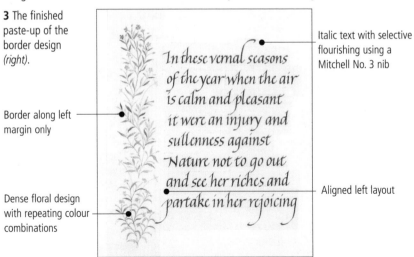

In these vernal seasons
of the year when the air
is calm and pleasant
it were an injury and
sullenness against
Nature not to go out
and see her riches and
partake in her rejoicing

Italic text with selective flourishing using a Mitchell No. 3 nib

Aligned left layout

COMPLETING THE PIECE

1 After pasting up, write out the final text. A heavy, hot-pressed paper has been used in this example.

2 Trace your design for the floral border. Placing a pad of paper under the drawing will help you obtain a good-quality line.

3 Transfer the traced design to its final position on the writing sheet by placing carbon paper between the tracing paper and the paper. Simply draw over the tracing, pressing firmly. Any unwanted marks can be removed from the paper with an eraser.

4 Colour the final illustration by applying watercolour with a fine brush. Note that the text is completed first, then the colour decoration. This is always the sequence of decorated calligraphic work: black text, gold (if used), and finally the colour is added.

What are some other possibilities for border designs?

To find inspiration for border designs, it is a good idea to study historical examples. Decorative borders from Eastern and Western manuscripts are an infinitely varied source of reference for contemporary calligraphy. These borders may influence your own designs, but try to use them in new and creative ways. The wealth of designs in Western manuscripts includes some coloured linear borders, which sometimes consist of different coloured bands of varying widths. These may be plain, divided into decorated rectangles, or feature repeating patterns of geometric or intertwined plant elements. Sometimes the border is the natural extension of a decorated initial letter.

A myriad of plant designs, including complex floral designs, are found in Flemish, French and Italian manuscripts from the late medieval period onwards. Whether realistic, stylised, or invented, floral borders are particularly suited for flowing calligraphic forms. Plant borders may be contained by coloured or gilded lines of suitable width, or can be left with the plants themselves forming the outer edges of the design.

Above: *An English Grant of Arms written in a late Gothic script. Its elaborately designed border motifs form an extension to the large illuminated capital letter.*

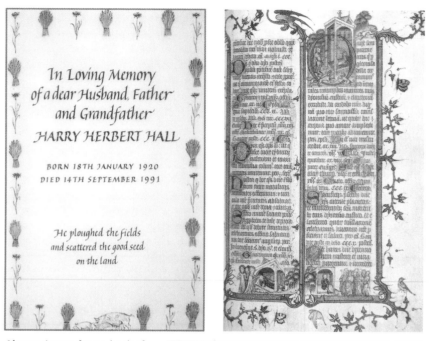

Above: *A page from a book of remembrance where the repeating border has been designed to reflect the life of the deceased.*

Above right: *The red and blue border of this fourteenth-century St. Denis missal 'branches' into the margins, softening the lettering.*

Right: *This charter, produced for the 500th Anniversary of the Drapers' Company, has beautifully detailed watercolour and gouache borders that combine plant designs with heraldic elements.*

What is a decorated letter?

Illuminated or decorative letters have been employed by calligraphers since medieval times to 'lighten' pages of text. In addition to this traditional application of decorative letterwork, designs based on a single letterform can also be used for greetings cards, letterheads and commemorative panels.

Decorative letters can encompass a vast array of different types of design – from medieval manuscripts, through intricate scrollwork, to colourful modern graphic treatments.

You don't have to be an expert illustrator to try your hand at decorative lettering. You can start by copying ideas from early manuscripts in a book of reproductions and adapting them to your own requirements – using your own colour choices, for example. Later, try adding illustration ideas of your own. Simple plant forms are a very useful source of inspiration to the calligrapher.

Versal letterforms were the traditional vehicle for medieval illumination; their built-up forms are ideal for the addition of colour or gilding. However, almost any script can be used in a modern context. In the project shown below and in the following questions, a single letter was decorated using gouache and gilding.

Left: The completed letter is mounted on a green greetings card from which a 'window' has been cut. In this example, a greeting was written on the plain paper fixed inside the card.

What is the first step in creating a decorated letter?

The first step is to produce a few rough annotated sketches, like the ones shown *(below)*, to explore the possibilities for a design. In this example, the design is based on the letter 'Q' using a form of Versal script known as Lombardic. This letterform, with its spacious counter and graceful tail, provides ample opportunities for decoration within and around the letter. The scrolling form of the tail, in particular, provides a starting point for a design based on curling tendrils of vine leaves. A major decision that you need to make at this stage, is how far to extend the decoration beyond the boundaries of the letterform.

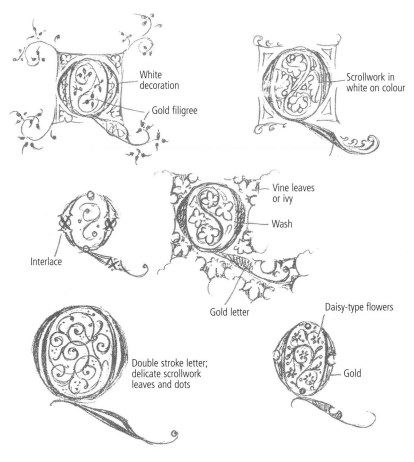

White decoration

Gold filigree

Scrollwork in white on colour

Vine leaves or ivy

Wash

Interlace

Gold letter

Daisy-type flowers

Gold

Double stroke letter; delicate scrollwork leaves and dots

How do I prepare final colour and complete the design?

Once you have selected the final design from your rough drawings *(see previous question)*, add some details and decide what colours you want to use. In this example, the calligrapher selected the square design, broken by the tail, which includes vine motifs outside as well as inside the letter. The triangular silhouette of the four leaves placed around the 'O'

form of the 'Q' makes up the corners of the square. The outside curves of the 'Q' are angled and the tail is given extra weight. Once you have fine-tuned your design details, make your preliminary colour choices. In this case, gold has been chosen for the letterform itself complemented by mauve and green decoration in gouache.

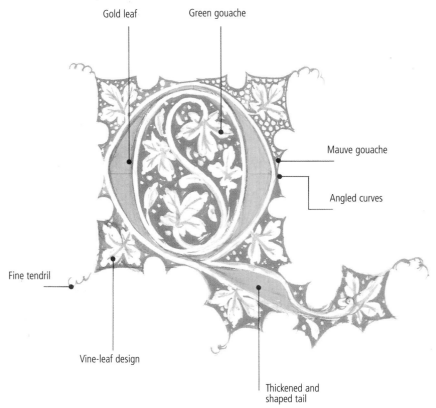

Gold leaf

Green gouache

Mauve gouache

Angled curves

Fine tendril

Vine-leaf design

Thickened and shaped tail

COMPLETING A DECORATED LETTER

1 Work up your final design on practice paper to allow for changes without damaging your final work. To transfer your design to your 'good' paper, place a piece of tracing paper over your final design and trace your drawing.

2 Turn tracing paper over and rub a graphite pencil over your design on the back side. Reposition your tracing in the design's final position on your 'good' paper, right side up. Draw over the design – the graphite on the tracing's back will transfer it to your 'good' paper.

3 Apply gold to the outline of your letter *(see page 180)*. Then, mix sufficient quantities of your chosen colours of gouache to finish the job. Apply the colour carefully to your work with a fine sable brush.

4 For the final version of this example, the calligrapher decided to use a muted green for the decoration inside the counter.

5 Complete the last elements of your design. Here, the final step is to complete the fine tendrils that extend from the corners of the design.

What is the first step in laying gold leaf?

After a letter (or image) has been drawn in pencil (**1**), use a pen or quill to apply the gesso to the area to be gilded (**2**). Let the gesso dry completely and apply additional coats if desired.

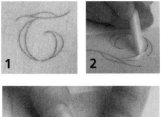

Moisten the gesso by breathing on it. This will allow the gold to adhere to the gesso. Place the gold leaf and its backing sheet (gold leaf side against the gesso). Rub gently with your finger, ensuring that the gold will stick to the gesso (**3**).

How do I get rid of the 'fringe' gold leaf and make my gold leaf shine?

After the gold and gesso have been allowed to rest for at least 30 minutes, the fringe gold can be gently brushed away with a soft brush or cloth (**1**).

You can get the gold leaf to shine by rubbing it with a burnisher (**2**). This will enable it to develop a shiny lustre.

Always remember the burnishing must be done when you are certain you will not be laying any more gold in that design. Gold will not stick to burnished gold.

After burnishing, the completed letter should be bright and shiny and look similar to the result shown here (**3**). You are now ready to put the colour or other decoration around your gold letter.

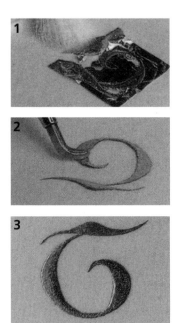

What kind of burnisher should I use?

Burnishers, which are used to polish gold, come in different materials and shapes. Agate, which is a semi-precious stone, is the best known and most widely available. Burnishers can also be made of haematite. This material stays dry even when conditions are humid, while the disadvantage of agate is that it absorbs moisture from the atmosphere. A haematite burnisher is shown here *(bottom left)*.

Psilomelanite is another alternative material and is less expensive to manufacture than haematite. However, it must be kept free of grease. A number of different burnisher shapes are available *(below)*. The three most common are flat, toothed and pencil. A pencil burnisher is so named because the agate comes to a rounded point – one is being used here *(bottom right)* to burnish around the edges of the gesso.

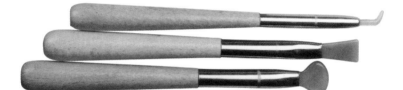

Designing and Finishing

How do I go about designing an invitation?

Formal invitations can be greatly enhanced by calligraphy, used alone or combined with type. Handwritten letters and simple letter decoration – usually by means of flourishing *(see chapter 5)* – can add the individual touch that type alone lacks.

Formal scripts, such as Italic, are ideal for occasions such as weddings, christenings, or banquets, but there are no hard-and-fast rules. The invitation could be written entirely in capitals, or in areas of upper- and lower-case letters to suit the text and overall design. You could consider combining compatible scripts, using an embellished capital, changing to a large nib for the main names or writing them in a different script. Even the most formal invitation for printing means preparing artwork in the form of a paste-up, with calligraphy written in black and with instructions for the printer in non-reproducible pencil. If you are reproducing the invitations by photocopying, they can be copied in black and white or colour on to white or coloured paper sufficiently thick to cut or fold into cards. Your invitation will usually need to comply to a regular size and shape used by the printer, and, if you work in a larger size, you will have to prepare your artwork to scale.

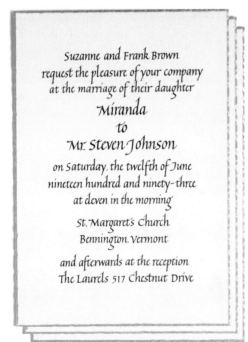

Left: *This invitation is printed on a white card with a silver deckled edge and the result is elegant and restrained. Prominence had to be given to the names of the bride and the groom, while conveying varying levels of information about the wedding and reception clearly and attractively.*

Do I start with a thumbnail sketch?

Yes. The first part in the planning process is to sketch out a few layout alternatives from the text supplied. At this stage, it is the format of the wedding invitation and the distribution of the words within that format that are the main concerns. Three options that all had centred text were tried *(right)*. The wide vertical format was selected for development.

Square format *(above)*

Wide vertical format *(above)*

Horizontal format *(left)*

How large should I make my lettering?

The next stage is to think about the style of lettering that you want to use and to experiment a little. Italic minuscules and capitals – being both formal and decorative – were the obvious choice for this kind of occasion. The precise details of width and spacing, however, needed to be worked out. An all-capitals version and three versions of the minuscules from wide to narrow were tried *(right)*.

Suzanne and Frank Brown
Compressed Italic minuscules with capitals

Suzanne and Frank Brown
Compressed and sharpened Italic minuscules with capitals

Suzanne and Frank Brown
Standard Italic minuscules

SUZANNE & FRANK BROWN
Italic capitals with slight flourishes

How do I choose paper for an invitation?

Your choice of paper or card stock for printed calligraphic work is subject to considerations that are different from those you use when selecting a surface to write on. Consider too the envelopes you will be using as they will determine the overall size of the finished invitation. They might also influence your paper selection. For printed work you are primarily concerned with colour, weight, and texture. Obtain samples *(below)* from the printer and judge them in relation to the colour of ink you are using and the overall effect you are aiming to achieve.

How do I prepare an invitation for printing?

To prepare an invitation for printing, you must paste up your artwork first. Your calligraphy needs to be presented in black and your printing instructions in non-reproducible pencil (so that the latter do not appear on the printed invitations). In most cases, you will need to select a standard paper size that your printer

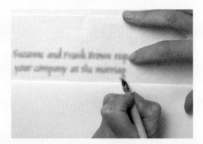

1 Write text for your invitation. The text shown here is written in Italic – with a Mitchell No. 4 nib – to 5 nib widths.

2 In this example, the couple's names are initially written in swash capitals, using a Mitchell No. 3 nib.

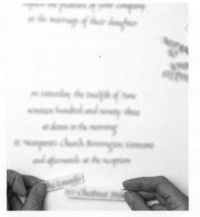

4 Cut your text into lines to assess the spacing of your paste-up by eye. When you judge the arrangement to be right, rule accurately measured lines to guide the final paste-up.

5 In this example, after the capitalized version of the couple's names is pasted up, it is compared with the minuscule version. The decision is made to substitute the minuscule script.

uses. In this example, the size of the writing *(Step 1)* will be reduced at the printing stage to the finished dimensions of the invitation. If you have graphic software and a scanner at your disposal, the lines of text can be scanned and the layout electronically manipulated instead of manually as shown here.

EXPERT TIPS

There are many ways to add interest to a wedding invitation. Simple decorative motifs can be very effective. You could also highlight the initial letters of the couple's names in order to draw the viewer's eye to them.

3 An alternative version using Italic minuscules (in the larger nib size), is tried for comparison.

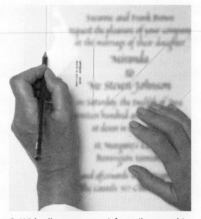

6 With all your text satisfactorily pasted in position, rule margins in blue pencil to show the printer the final proportions required. The margins must be in proportion to the size of the final printed invitation.

Mr.& Mrs **M**ichael **K**night
request the pleasure of the company of

at the marriage of their daughter
Helen **L**ouise
to
Andrew **R**onald **R**aymant
at the parish church of St Michael
Chenies, Buckinghamshire
on Saturday 27th July
at 2·00 p.m
and afterwards at a reception
at Chenies Manor House until 7·30p.m

RSVP. 7 Hamble Close, Ruislip, Middlesex HA4 7EP

Can I see other examples of hand-lettered wedding invitations?

Calligraphy in invitation design can be used on its own or in harmony with type. Flourishes are a natural choice to enhance invitations but other decorative elements may also be used to great effect. Sensitivity of design can extend to the choice of paper, the way in which the invitation is folded, and the addressing of the envelope. Creating invitations is an excellent way of putting calligraphy to practical use.

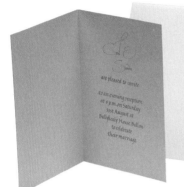

Left: *This lovely pair of invitations – one to the wedding, the other to the reception – show the elegant use of flourished Italics.*

Right: *This delicate design is printed on fine-quality white paper with an original touch added by the use of Japanese lace paper backing.*

How do I design a letterhead?

Designing a letterhead can be straight-forward and rewarding for beginners or can provide design challenges for more advanced calligraphers.

You will need to consider which style of lettering is most appropriate to your client. If you want the letterhead to look quiet and formal, a Roman book hand or formal Italic is a good choice; if eye-catching and lively is your aim, a vigorously written cursive Italic could work well. Relative emphasis within the design can be provided by variations in size, weight, colour and letterform.

Questions to ask yourself are Do you want a close vertical texture for impact or wide spacing for elegance? Is the alignment to be to the right, left, centred, or asymmetrical? Do you want to incorporate a simple or sophisticated motif or logo? And how is the letterhead to be placed on the page? You must also check with your printer about how he or she wants it to be submitted.

Left: *This letterhead has been designed for a ceramics studio and needed to convey the handcrafted character of a professional business. The company logo can also be used on a business card.*

Do I start with a thumbnail sketch when designing a letterhead?

No, in this case you need to start with lettering style. The first task is to choose a script that is in keeping with the image the business wants to project. Uncials and Half Uncials seem good initial choices for this company's letterhead as it has craft-based associations. Here, *(below)* various scripts are tried at different nib widths; the Half Uncial script, with its attractive rounded letterforms, is selected for development.

The studio

Little haven — Serifed Uncials at 4½ nib widths

Half Uncials at 4 nib widths — the studio

little haven

The studio

little haven — Uncials at 3½ nib widths

How do I work out a layout?

Having decided on a script, the next stage is to work out a layout. The main issues are the size of the lettering and its alignment. Rough pencil sketches are adequate for this purpose. The calligrapher has decided here *(below)* that the name of the business should be rendered in the largest size. The relative size of the rest of the text needs to be worked out. Experiments with a logo are also tried at this stage.

Centred layout, two text sizes

Ragged left-aligned layout, three text sizes

Left-aligned layout with logo, three text sizes

Right-aligned layout, three text sizes

Centred layout | All lettering in Half Uncials | Three sizes of text

Pen-drawn logo

How do I prepare final artwork for a hand-lettered letterhead?

The steps below show you how to prepare a leterhead for the printer. In this case, a Mitchell No. 0 nib is used, which produces lettering that is larger than it will appear in the final printed form *(Step 1)*. This is done because reduction sharpens the letterforms. If you have graphic software and a scanner at your disposal,

1 Write large-size lettering between lines ruled to 4 nib widths. A Mitchell No. 0 nib is used here.

2 Because the letterhead is to be printed from a paste-up, you can paint out small imperfections in opaque white. This is a bleed-proof paint that effectively covers any underlying ink.

3 Draw the artwork for your logo (a Mitchell No. 0 nib is being used here). If you want your logo to have a rough appearance, choose a heavy textured watercolour paper.

4 Before pasting down the lettering and artwork, make your final adjustments to your layout. Rule guidelines for the paste-up.

5 Paste up photocopies of each element in position – reduced in size where necessary – to show the final effect.

6 Measure the intended size of each element from the paste-up and calculate it as a percentage of the original in order to instruct the printer about the correct reduction.

the lines of text can be scanned and the layout electronically manipulated rather than manually manipulated as described here. When briefing the printer, provide clear instructions about the colour of the type and about the type of paper you want to use. Ensure that you see samples before printing.

7 Measure and note the exact positions of the artwork and lettering from the paste-up.

8 Mark the margins and precise guidelines for the positioning of the letterhead on the paper for a final 'camera-ready' paste-up for the printer. Use a non-reproducible pencil that will not show up in the printing.

9 Your final paste-up of the artwork is ready for the printer.

EXPERT TIP

A letterhead can be easily adapted and redesigned for complementary company stationery. This business card has been created in the shape of a diamond, with a ribbon added for an original touch.

Can I see examples of other letterhead designs?

Letterheads provide a design challenge. Whether you are commissioned to design a formal and understated image or something eye-catching, the creation of an appropriate image is an excellent design opportunity. The letterheads by skilled calligraphers shown on this page *(below)* illustrate a few possibilities.

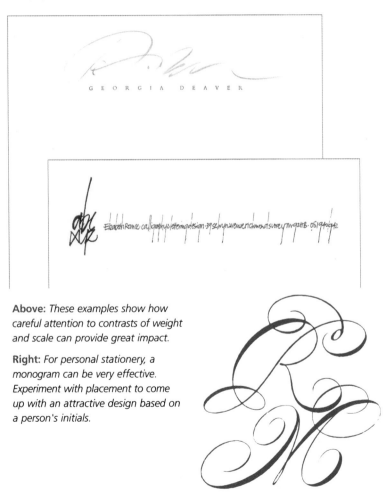

Above: *These examples show how careful attention to contrasts of weight and scale can provide great impact.*

Right: *For personal stationery, a monogram can be very effective. Experiment with placement to come up with an attractive design based on a person's initials.*

Is it possible to combine several pieces of poetry into one project?

A broadsheet is a single sheet of paper containing one or more poems, sections of a poem, or pieces of prose that are linked by theme and can be read across the sheet, with no need to turn pages. A broadsheet design should not be too complicated or it may detract from the meaning of the text and appear contrived. A simple approach is often the best one. Your choice of quotations is crucial, because a personal interest in the theme will give the work excitement and a sense of discovery. In the broadsheet shown here *(below)*, texts are 'hung' around a central piece of writing. The scripts were chosen to create an interplay between the central and the surrounding texts, while harmonious colours, repeated shapes and images and gentle contrasts serve to unify the design.

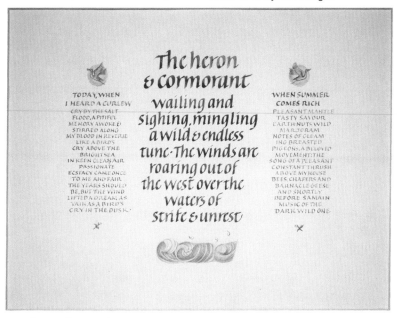

Above: *The completed panel shows a delicate harmony of text and illustration. A finished broadsheet can be framed and displayed.*

How do I design a poetry broadsheet (or broadside)?

You can develop the initial design ideas for both the text and the illustration in a broadsheet simultaneously. These useful little sketches, with their accompanying notes, show the development of the calligrapher's illustration ideas. Broad areas are sketched to represent the component elements so that the final design will form a unified whole.

The design *(below)* is a triptych with the main text placed centrally and two subsidiary texts on either side. At this stage, the notes indicate that there is a plan for the focus of the piece to be reinforced by rendering the main text in a darker tone than the subsidiary texts. As you will note *(see page 197)* this decision was later partially reversed.

How do I work through the sketches to come up with a final design?

To prepare a final design you need to refine your ideas in a rough layout. In this example, the calligrapher has decided on the positions of the three component poems and the illustration areas. In order to make the rough design as accurate as possible at this stage, the text has been rendered in Italic script and in colours approximating those to be used in the finished piece.

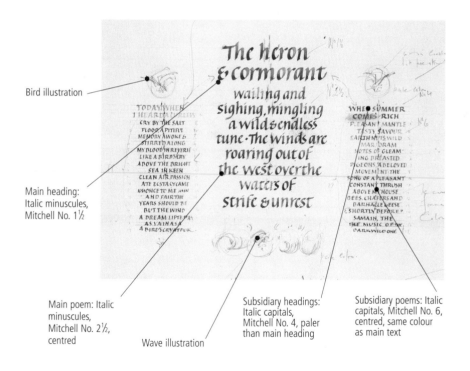

Bird illustration

Main heading: Italic minuscules, Mitchell No. 1½

Main poem: Italic minuscules, Mitchell No. 2½, centred

Wave illustration

Subsidiary headings: Italic capitals, Mitchell No. 4, paler than main heading

Subsidiary poems: Italic capitals, Mitchell No. 6, centred, same colour as main text

How do I finalise the design and paste up a poetry broadsheet?

To make a paste-up of the final design, you will need to make photocopies of the text and cut strips out ready to put them in position. As you will see from the photographs in this example *(below)*, the calligrapher needed to make some decisions about various aspects of design and colour during the pasting-up process –

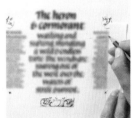

1 The initial writing of the text uses the selected colours in order to judge their effect. Different colours are tried out on scraps of paper first.

2 Photocopies of the text are pasted in position. The central panel is placed first. Care is taken to ensure that the panels are evenly balanced with equal numbers of lines. Several attempts are needed.

3 With all elements placed in position, measurements of the line spacing are taken from the paste-up to be transferred to the final version.

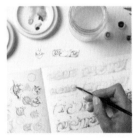

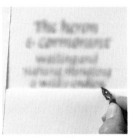

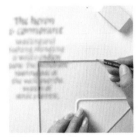

4 The calligrapher experiments with a number of different colour treatments. Here a very muted yellow wash is painted over a pencil drawing.

5 The final writing is started. The central panel is completed first, because its position determines the placement of the other elements.

6 Using the paste-up as a guide, ruled lines to mark the position of the side panels are drawn in relation to the central panel.

and to do so she had to experiment with different treatments first *(Steps 1 and 4)*. Once the piece was ready, she made a final decision about margin sizes *(Step 9)*.

This layout creates interest by using contrast, in this case by writing with several different pen nib sizes, as well as different colours and lettering styles.

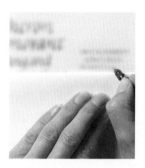

7 The side panels are written along the ruled guidelines.

EXPERT TIP

One way of giving your poetry broadsheet more impact is by combining contrasting styles and sizes of lettering.

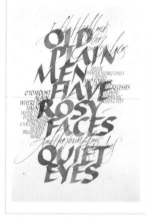

8 The illustrations are the last element to be added. They are carefully drawn in pencil before the coloured washes are put in.

9 L-shaped cards are used to judge the margins, and these are pencilled in. The broadsheet is later trimmed and a mat is added for display.

Can I see some examples of poetry calligraphy work for inspiration?

The examples here *(below and opposite)* show personal responses to poetry text expressed in calligraphic terms. For all calligraphers, poetry and literature in general can serve as a major stimulus for creative work. When you are working from soundly understood letterforms, you can use poetry to explore variations in weight, slope and layout. Colour too can express the mood of the poem, from bright and energetic to quietly harmonious – it's the calligrapher's choice.

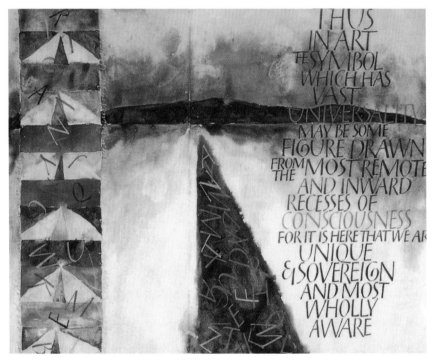

Above: *This imaginative interpretation of a text by Karl Young uses a close-knit vertical texture of different-size Versals. The various changes in colour set off the lettering from the background that links the elements of the design.*

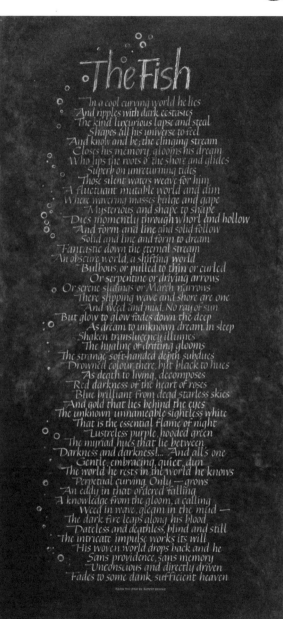

Can calligraphy be used in poster design?

Calligraphy can be a striking alternative or complement to print in poster design. A successful poster should be eye-catching and present the essential information clearly so that it can be read 'on the run.'

You can produce an attractive poster at low cost, even if it has to be in a single colour *(below)*. Designing for one colour can stimulate imaginative use of both contrasts created by the lettering itself and of the space in and around the text.

Colour can be introduced, if needed, by using coloured paper or by adding a splash of colour by hand to each poster.

Some posters suffer from 'overload,' with too much happening and no focus; others are simply dull. You can use lettering alone – or choose suitable imagery – to make a focal point. Create an atmosphere by wise choice of lettering styles and sizes and by considered use of space and illustration (if needed).

Left: *The poster shown here is a low-budget design for a jazz concert to be printed in black on a photocopier. The poster needs to suggest a dynamic but controlled atmosphere while conveying a clear and eye-catching message.*

What are the first steps in designing a poster?

The client usually supplies the text for the poster in the form of typed copy. The first task is to organise the text into 'bite-size' pieces and sort them according to their relative importance *(below)*.

Next, try some layout ideas on sketches, incorporating different sizes and styles of lettering *(bottom)*. The word 'JAZZ' has been picked out to provide the main focus. The last thumbnail combines the best elements, with the broken black band creating contrast and emphasis, leading the eye down the poster to the subsidiary information.

TENTH ANNIVERSARY OF JAZZ AT THE WAREHOUSE

SPECIAL FREE CONCERT (WITH) ROY LEWIS BAND

(ON) THURSDAY 18th MAY (AT) 8pm (AT) THE WAREHOUSE

RIVERSIDE SELBY (NOTE:) FACILITIES FOR

WHEELCHAIRS (AND) BAR

Above: *In this example of edited copy, the calligrapher has suggested a number of ways for making the final wording of the poster punchier.*

This thumbnail shows a horizontal orientation, with upturned lettering at left margin.

Focus in the lower half with diagonal elements.

Focus in upper half, aligned left.

Focus in upper half, aligned left to the solid band in margin.

Focus in upper half; solid bands at top and bottom, aligned left.

Focus in upper half; main lettering breaking into band in left margin.

How do I complete a paste-up for a poster?

In the final rough *(right)*, the addition of horizontal lines above and below the word 'JAZZ' strengthens the focus. At this time decisions on letterform, weight, and size should be firmed up. All the lettering is in compressed Italic, which conveys an appropriate sense of controlled energy. Variations in size and weight provide different levels of emphasis.

Once you have a final rough of your design, you are ready to complete your poster. Even at this stage it is still possible to fine-tune the size and weight of the lettering as you paste your text in and make fine adjustments to text positions *(Steps 1 to 4)*. If you have graphic software and a scanner at your disposal, the lines of text can be scanned and the layout electronically manipulated rather than manually manipulated as described here. When you have completed your

Mitchell No. 2 nib
Thin rule
20mm (¾in) nib
Thick rule
Mitchell No. 2 nib
Mitchell No. 0 nib
8mm (¼in) nib
Mitchell No. 2 nib
Mitchell No. 3 nib
Solid black band

1 Write out your text in preparation for a preliminary paste-up. Here the main word is written using a 12mm (½in) plain-stroke pen.

2 Complete the paste-up using photocopies of the lettering. In this example, 'JAZZ' has been rewritten using a 20mm (¾in) nib.

3 Take measurements of line spacing from the rough paste-up and transfer them to the final (camera-ready) paste-up for the printer.

paste-up you can make the decision whether to print on white paper or choose one of the many different coloured papers. For this poster, green paper was selected for the final print-run.

EXPERT TIPS

- *Try providing a sense of movement by introducing diagonal elements to your calligraphy (right).*

- *Very strong colours on a dark background are a great way to attract attention to your poster. Note the effectiveness, in the example shown here (right), of the use of complementary colours and analogous colours in the same piece.*

4 Place text in its final position on the paste-up for the printer. Use tweezers for accurate placement.

5 Draw black bands and rules with indelible felt-tip pens. Any marks and paste-up edges can be covered using correction fluid (or opaque white paint).

6 Use a fine marker pen to fill any unevenness in the rules and to ensure the black areas are 'solid'. The poster is now ready for reproduction.

Is there a simple bookbinding method I can use for my calligraphy?

This type of simple folded book, which is also a display panel, is a popular application for calligraphy. It combines the opportunity to use a relatively long text at a convenient size, with the challenge of having to design pages that work well when fully opened as well as individually. The need for the design to flow smoothly and horizontally throughout the book provides interesting possibilities for both the calligraphy and the illustration. Colour can often provide a unifying element through the book. The other advantage of using this technique is that it avoids a lot of sewing and gluing.

The concertina book shown here makes use of an anonymous medieval poem about the seasons. The simplicity of the words seems to lend itself well to this intimate treatment, and the continuous nature of a concertina book works

successfully with the idea of the seasonal cycle. The illustration motifs come from medieval symbols for the seasons.

Above and below: *This horizontal format book folds neatly into its cover. Because the cover is fixed only at the front, the book can be opened and extended to show all its pages in a single view.*

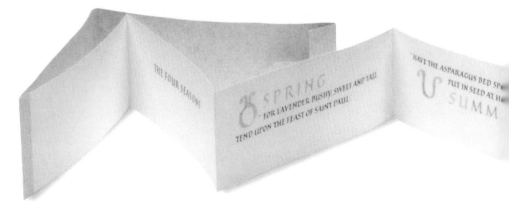

Do I need to do thumbnail sketches for a concertina book?

Yes, you do. In this example, a decision had been made to use a horizontal format with illustrations based on the medieval symbols for the seasons. However, the size of the lettering, the relationship of the headings to the text and the position and treatment of the motif still needed to be worked out in more detail.

Shown *(right)* are the thumbnails of various layouts that were tried. The position of the motif at the left of the page remained constant as did the rendering of the text in italic capitals. The major questions that had to be resolved at this stage were the size, weight and spacing of the text. The thumbnails show how different ideas for the layout were considered, although none of these solutions was eventually selected for development. The idea of widely spaced lettering for the heading proved too weak, and a more conventional letter spacing was adopted *(below)*.

S P R I N G

FOR LAVENDER, BUSHY SWEET AND TALL
TEND UPON THE FEAST OF SAINT PAUL

S P R I N G

FOR LAVENDER BUSHY SWEET AND TALL
TEND UPON THE FEAST OF SAINT PAUL

S P R I N G

FOR LAVENDER BUSHY, SWEET AND TALL
TEND UPON THE FEAST OF SAINT PAUL

S P R I N G

FOR LAVENDER BUSHY SWEET AND TALL
TEND UPON THE FEAST OF SAINT PAUL

How do I complete my concertina book?

Before you paste up your book you need to think about its final size and margins. Any page proportion is possible with a concertina book and can be varied to enhance interpretation – for example, a text about open spaces could have very wide margins. Before you start your paste-up *(Step 1)*, make your final decisions about heading style and letter spacing. Consider some interesting design

1 Write your text and paste it up with the symbol. The verse in this example has been written with a Mitchell No. 4 nib and the heading with a No. 2½ nib.

2 Your final paste-up should show the arrangement of the symbol, heading, and verse on the page. A paste-up is needed for each page.

3 Choose your paper and test your selected colours on it – for this book, a pale cream, textured paper is chosen. The paper needs to be suitable for both ink and watercolour.

4 Stencil your motifs. The first stage is to trace each pen-drawn motif in pencil.

5 Put a piece of low-tack masking film carefully over your tracing.

6 Cut out the traced symbol with a craft knife, accurately following the drawn outlines.

elements, such as stenciling or a spatter technique *(see pages 138 and 140)*, to add an extra dimension. When you have completed your final paste-up *(Step 8)*, make the cover *(Step 9)*. You will need to cut it larger than your book – allow 3mm (⅛in) extra at the top and bottom, plus 13mm (½in) at the front. You will also need to make a 25mm (1in) flap with a 50mm (2in) tab at the back *(Step 9)*.

7 Peel away the masking film carefully from the tracing paper and place it so that the symbol is in its final position on the paper. The surrounding paper should be carefully masked. Mix and spatter your chosen colours over the stencil using a stencil brush.

8 Write your text in black ink in the positions specified by the final paste-up.

HAVE THE ASPAR

EXPERT TIP

Instead of using stencils to create your motifs, you could use rubber stamps. In the example shown (below) *rubber stamp motifs are used alongside text written in a basic Roman book hand.*

9 Cut your cover *(see guidelines in introduction, above)*. Score the folds of the cover and glue the front flap to the first page only as shown in the photo *(pages 206 and 207)*.

Can I see other similar concertina book examples?

There are many different ways to design a concertina book using lettering and illustration. As the examples show *(below)*, this type of book is an attractive and manageable project for a someone who is starting to learn calligraphy.

Above: *This attractive concertina book, based on the signs of the zodiac, incorporates subtle illustrations over painted background squares.*

Left: *This unusual book consists of two concertina sheets with slits that are slotted together vertically.*

How do I make a book with a sewn binding for my calligraphy piece?

In calligraphy, a book with a sewn binding is called a manuscript book. Both beginners and the more experienced can make an attractive manuscript book as it allows straightforward treatment of a short text as well as more elaborate writing and design. Books can have one or many sections and illustration can range from a simple decorative element, such as a symbol, to ornate illumination. A single section is best for a first book.

Traditionally a single-section book consists of sixteen pages – including a title page and several blank pages at the beginning and end of the book, so that there are about five to seven pages of writing – but there can be fewer if you prefer. You could include a discreet colophon at the back of the book, giving your name and the date of writing. A simple cover, with or without decoration, will complete your project.

Above and right:
A manuscript book is made up of sheets folded in half – each comprising four pages of the book. These are called folios.

Do I start with informal sketches?

Yes, after reading the text and getting a feeling for its overall character, jot down some preliminary layout ideas. At this stage you should consider format, page size and first thoughts on the script to be used. It is also important to consider the design of your double-page spreads.

The thumbnail sketches *(below)* indicate some of the options tried for this project. After reviewing these possibilities, the calligrapher decided to pursue a relatively wide vertical format.

Large capital start, left-aligned text

Drop capital start

Large Italic capital start

Centred capital start

Wider vertical format

Spaced capital start

Horizontal format

Narrow vertical format

Can I use more than one lettering size?

Yes, having decided on the format, it is possible to work out the treatment of the text in more detail. In these layout roughs *(below)*, although the text is humorous, the calligrapher has decided not to overemphasise this by using a zany script.

A plain Italic has been selected as it has the right feeling of simplicity. However, to give texture to the page and to provide variation in pace, larger coloured capitals are chosen for the paragraph openings – experiments are shown here *(below)*.

How do I work out the margins?

If you are a beginner, draw margins following the standard formula for producing margins, in which the outer margin is twice the inner one and the bottom margin is twice the top margin. Here are two examples – one sixteenth-century *(right)* and one contemporary *(below)*, showing the use of this proportion.

What are the steps I need to follow to make a manuscript book?

Before you paste up your manuscript book you will need to have made decisions about the relationship between text area and margins, page size and shape, length of writing line, size, weight and styles of writing – and the choice of writing and binding materials. As you paste up you can fine-tune some details, then you are ready for the final writing stage *(Steps 7 to 9)*.

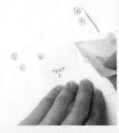

1 It is a good idea to prepare a miniature book that allows you to check and number the pages.

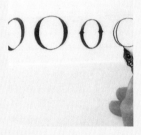

2 Try out various styles of introductory capitals, if using them. Here the calligrapher tries Italic and Versal ones and decides to use Versals.

3 Rule margins on a sheet of paper for the paste-up.

7 The next stage is the final writing. In this example, with the Versal capital pencilled in, the small black lettering is written first.

8 The calligrapher uses a large capital and completes it next in blue gouache. Then he pencils in the introduction in small capitals.

9 Finally the calligrapher completes the text by writing the small capitals in pen in the same blue gouache.

EXPERT TIPS

- Create a title page for your manuscript book to reflect the style and mood of its contents, like the one shown here (right).
- The weight of the paper you use is important. It needs to be thin enough to fold easily, but thick enough so as not to allow too much 'show through'.

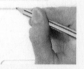

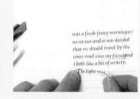

4 Rule lines to act as guides for the paste-up, based on the preliminary decisions you made when selecting the letterform.

5 Write out your text for the rough paste-up. In this example a Mitchell No. 4 nib and black watercolour have been used.

6 Cut out the written text and paste the strips in position on the writing lines. Tweezers are useful for picking up and positioning pieces of text.

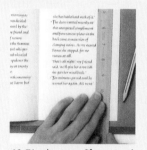

10 Trim the pages (if necessary) and assemble in the correct order. Place your book on the cover paper and mark the dimensions of the cover.

11 Sew the trimmed cover and book together with strong thread (see page 216).

12 This finished book has a calligraphic cover that echoes the treatment of the inside pages.

How do I make a cover for my book?

A manuscript book needs a well-made cover to protect the inner pages. It should be made from heavyweight paper that will withstand handling. Once you have trimmed and folded the cover, sew it to the text pages as shown below.

FOLDING THE COVER

The cover should be larger than the page dimensions; allow about 6–12mm (¼–¾in) extra at the top, bottom and outside edges. Give the cover generous flaps of about two-thirds the cover width. Once the cover is cut, score the inside folds of the spine and flaps using a pointed, but not sharp tool, such as the ends of a closed pair of scissors.

SEWING THE COVER

Carefully position the folded folios inside the cover. Pierce stitch holes from the inside fold of the centre folio through the outside spine fold of the cover. Using heavyweight thread and a strong needle, pass the needle through the middle hole in the inside fold in the centre folio, leaving a long loose end as shown. Continue to sew following the sequence here. Be careful not to divide the thread as you pass through a hole for the second time. To finish, tie the two loose ends together inside the book and trim.

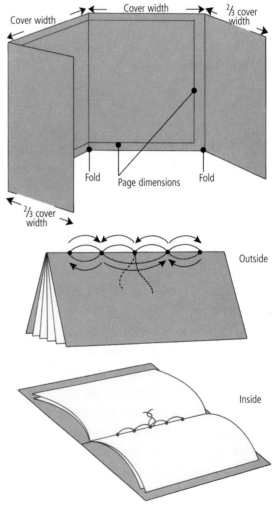

Cover width

Cover width

Cover width

²/₃ cover width

²/₃ cover width

Fold

Page dimensions

Fold

Outside

Inside

Are there samples of manuscript books that I can look at?

The manuscript books below illustrate how a well-written classical format has great serenity and elegance. This selection also demonstrates that beautifully written lettering has its own decorative quality, but that illustration sensitively blended with the text can enhance the overall design.

Whether you choose a simple or complex design, or a contemporary or traditional approach, making a manuscript book is a feasible project for calligraphers at every stage of learning. It is an intimate design vehicle for a thoughtful and personal approach to your calligraphy.

Left: *This spread combines grey gouache text and watercolour illustration. The wide margins enhance its delicacy.*

Below, left: *This elegant double-page spread of a Shakespearean text written on vellum demonstrates the timeless quality of a well-written italic.*

Above: *This centrefold shows an unusual and sensitive presentation of a double-page spread.*

ARCH The part of a LOWER-CASE letter formed by a curve springing from the STEM of the letter, as in 'h', 'm' and 'n'.

ASCENDER The rising stroke of a LOWER-CASE letter.

BASELINE Also called the writing line, this is the level on which a line of writing rests, giving a fixed reference for the relative heights of the letters and the drop of DESCENDERS.

BODY HEIGHT The height of the basic form of a LOWER-CASE letter, not including the extra length of ASCENDERS and DESCENDERS.

BOOK HAND Any style of alphabet commonly used in book production before the age of printing.

BOWL The part of a letter formed by curved strokes attaching to the main STEM and enclosing a COUNTER, as in 'R','P', 'a' and 'b'.

BROADSHEET A design in calligraphy contained on a single sheet of paper, vellum or parchment.

BUILT-UP LETTERS Letters formed by drawing rather than writing, or having modifications to the basic form of the structural pen strokes.

CHARACTER A typographic term to describe any letter, punctuation mark or symbol commonly used in typesetting.

COLOPHON An inscription at the end of a hand-written book giving details of the date, place, scribe's name or other such relevant information.

COUNTER The space within a letter wholly or partially enclosed by the lines of the letterform – within the BOWL of 'P' for example.

CROSS-STROKE A horizontal stroke essential to the SKELETON form of a letter, as in 'E', 'F' and 'T'.

CURSIVE A handwriting form where letters are fluidly formed and joined, without pen lifts.

DESCENDER The tail of a LOWER-CASE letter that drops below the BASELINE.

FACE (abb. **TYPEFACE**) The general term for an alphabet designed for typographic use.

FLOURISH An extended pen stroke or linear decoration used to embellish a basic letterform.

GESSO A smooth mixture of plaster and white lead bound in gum, which can be reduced to a liquid medium for writing or painting. It is used for a variety of purposes including providing an adhesive base for gold leaf in GILDING.

GILDING Applying gold leaf to an adhesive base to decorate a letter or ORNAMENT.

HAIRLINE The finest stroke of a pen, often used to create SERIFS and other finishing strokes, or decoration of a basic letterform.

HAND An alternative term for handwriting or SCRIPT, meaning lettering written by hand.

ILLUMINATION The decoration of a MANUSCRIPT with gold leaf burnished to a high shine; the term is used more broadly to describe decoration in gold and colours.

INDENT To leave space additional to the usual margin when beginning a line of writing, as in the opening of a paragraph.

ITALIC Slanted forms of writing with curving letters based on an elliptical rather than a circular model.

LAYOUT The basic plan of a two-dimensional design, showing spacing, organisation or text, illustration and so on.

LOGO A word or a combination of letters designed as a single unit, sometimes combined with an illustrative element; it may be used as a trademark, emblem or symbol.

LOWER-CASE Typographical term for 'small' letters as distinct from capitals, which are known in typography as upper-case.

MAJUSCULE A capital letter.

MANUSCRIPT A term used specifically for a book or document written by hand rather than printed.

MINUSCULE A small or LOWER-CASE letter.

ORNAMENT A device or pattern used to decorate handwritten or printed text.

RAGGED TEXT A page or a column of writing with lines of different lengths, which are aligned at either side.

RIVER The appearance of a vertical rift in a page of text, caused by an accidental, but consistent, alignment of word spaces on following lines.

RUBRICATE To contrast or emphasise part or parts of a text by writing in red; for example headings, a prologue or a quotation.

SANS SERIF A term donating letters without SERIFS or finishing strokes.

SCRIPT Another term for writing by hand, often used to imply a CURSIVE style of writing.

SERIF An abbreviated pen stroke or device used to finish the main stroke of a letterform; a HAIRLINE or hook, for example.

SKELETON LETTER The most basic form of a letter demonstrating its essential characteristics.

STEM The main vertical stroke in a letterform.

VERSAL A large decorative letter used to mark the opening of a line, paragraph or verse in a MANUSCRIPT.

WEIGHT A measurement of the relative size and thickness of a pen letter, expressed by the relationship of nib width to height.

WORD BREAK The device of hyphenating a word between two syllables so it can be split into two sections to regulate line length in a text. Both parts, ideally, should be pronounceable.

X-HEIGHT Typographic term for BODY HEIGHT.

Page numbers in italics refer to illustrations.

224 Acknowledgements

Material in this book has previously
appeared in:

The Calligrapher's Companion
The Complete Calligrapher
The Calligrapher's Handbook
Practical Calligraphy
An Introduction to Calligraphy
The Complete Guide to Calligraphy
Calligraphy School

The Publishers would like to thank all the
calligraphers whose skilful work is included
in this book.

*Unless otherwise indicated, images are the
copyright of Quantum Publishing.*

Key: top (t); centre (c); bottom (b); left (l); right (r).

2 Gaynor Goffe / Anna Ravenscroft. **6** Winchester Bible (l), George Evans (r). **7** John Smith (l),
Kate Ridyard (r). **21** Dreamstime (t). **37** Shutterstock (all images). **49** Ieuan Rees (br).
53 Janet Mehigan. **59** Carol Thomas. **62** Mary Noble. **65** and **68** Janet Mehigan. **72** Ian Garrett.
75 Juliet Jeffery. **78** Janet Mehigan. **81** Frederick Marns. **86** Ian Garrett. **88** British Library.
89 Gaynor Goffe / Anna Ravenscroft. **91** Dover Publications. **92** Paivi Vesanto. **97** Lawrence R. Brady.
98 Dover Publications (t); Gillian Hazeldine (b). **99** Christopher Haanes. **101-102** George Evans.
106 George Evans. **108-109** George Evans. **117** Anna Ravenscroft. **120** Louise Donaldson (l),
Gaynor Goffe and Anna Ravenscroft (r). **121** Anna Ravenscroft. **122** Diana Hoare. **125** Shutterstock.
147 Terry Paul. **148** Julia Vance (l), Paivi Vesanto (r). **149** Dave Wood (t), Polly Morris (b). **150** Kate
Ridyard (t), Monica Dengo (b). **153** Brian Walker. **152** Werner Schneider. **153** Timothy Botts.
156 Alan Wong (l). **159** Page from the Codex Aureus. **160** Donald Jackson. **170-172** Gaynor
Goffe. **173** V&A Museum. **174** Gaynor Goffe (tl), V&A Museum (tr), Joan Pilsbury and
Wendy Westover (b). **176-178** Timothy Noad. **180** Donald Janson (bl). **183** Nancy R. Leavitt.
184-187 Gaynor Goffe (invitations project). **187** Timothy Noad (r). **188** Angela Hickey (t), Bonnie
Leah (b). **189-193** Lorraine Brady (letterhead project). **193** Bonnie Leah (r). **194** Georgia Deaver (t),
Elizabeth Rounce (c), Fotomas (from Natural Writing by George Shelley, 1709) (b).
195-199 Anna Ravenscroft (poetry broadsheet project). **199** Louise Donaldson (r). **200** Nancy R.
Leavitt. **201** Janet Mehigan. **202-205** John Neilsen (poster project). **205** Jenny Kavarana (tr).
206-209 Penny Price (concertina book project). **209** Anne Irwin. **210** Patricia Lovett (t), Mary
Noble (b). **211-216** John Neilsen (manuscript book project). **213** Joan Pilsbury (bl), V&A Museum (br).
215 Karlgeorg Hoefer (tr). **217** Hazel Dolby (t), Joan Pilsbury (bl), Suzanne Moore (br).

*While every effort has been made to acknowledge all copyright holders, we apologise if
any omissions have been made.*